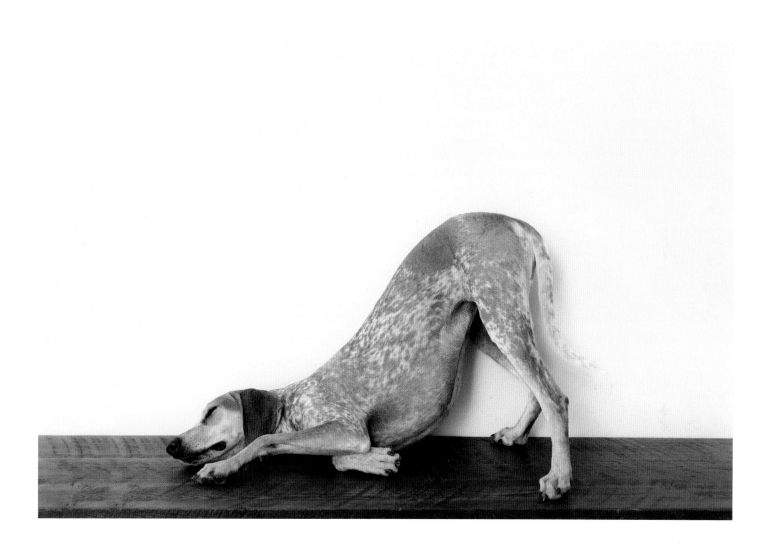

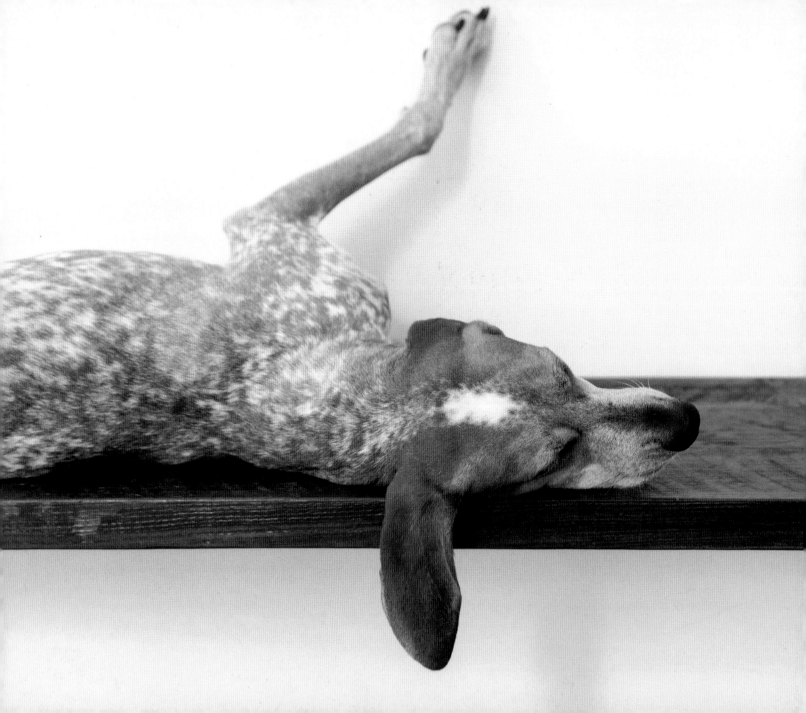

MADDIE
LOUNGING ON THINGS

A Complex Experiment Involving Canine Sleep Patterns

THERON HUMPHREY

ABRAMS IMAGE, NEW YORK

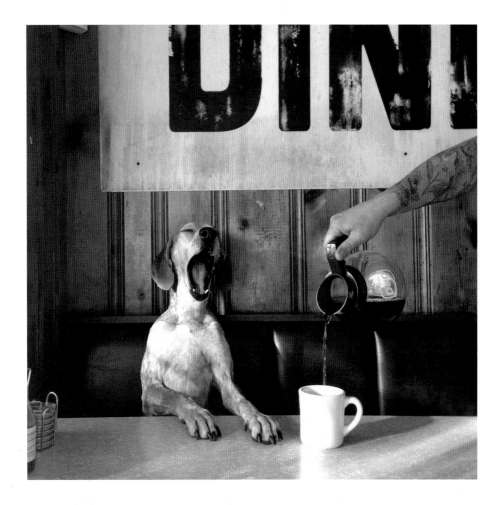

↗ **Home grown** / Atlanta, GA

This is one of those serendipitous moments you couldn't recreate if you tried for a year. Everything just fell right into place. I've eaten at this diner more than a few times and the owners are as kind as they come. I asked if I could shoot Maddie being poured a cup of coffee for a photo idea I had. As my buddy was pouring the coffee, Maddie just started to yawn on her own. I remember thinking, "Oh my gosh, this is amazing, this is amazing" when I was shooting. For sure one of the most magical images I've taken. Other interesting little details: Even though I shot this on an iPhone 4, this image was published in *National Geographic*, and it has circled the Internet more than once.

Introduction

////////////////////////////////////

I first met Maddie back in 2010. I remember walking down a long hall of adoptable dogs at an animal shelter outside Atlanta, Georgia, looking for her kennel number, which they give ya at the front desk. I put her on a borrowed leash and took her toward the playroom so I could get a better sense of how our personalities would fit. I let her off the leash and she trotted around the entire perimeter of the room a few times. She sniffed all the corners, jumped up and looked out the windows, and filled her lungs with the air coming in from the crack under the door. I must have sat on the floor for ten minutes hoping this dog I just met would come say hi, maybe even sit on my lap. But she never did. If I'm being real honest, I was a bit bummed about it. She was a beautiful dog with neat spots and I wanted her to like me. After realizing she wasn't going to pay me any mind, I put her back on the leash to take her back to her kennel. On that walk back something really simple but profound happened. She pressed the weight of her body against my legs. It was like the feeling you

get when you hold the hand of someone you love a whole bunch. Maddie won my heart on that walk. There was no way I could put her back in that kennel, so I turned around and took her to the front desk. They asked for forty dollars and for me to treat her right, and then said I could take her with me. Looking back now, it's fun to see how tiny subtle details in life change everything.

Maddie and I spent the better part of four years on the road wandering around, shooting photo projects. By now we must have traveled the lower forty-eight states at least three times, weaving in and out of small towns and long stretches of interstate miles. At the time I didn't even realize I was hunting anything, I thought I was just out there to see all those sunsets and nooks I never knew existed. But after finally hanging my hat and being embraced by such a wonderful community of vulnerable folks in Nashville, Tennessee, it became so clear I was using travel to numb feelings.

Good things often get used in unhealthy ways. Travel is a gift, but for way too long I was using it to cope. I was running from the childhood trauma of physical abuse. That's a pretty human response to things in our past that we haven't unpacked and healed from. We try to distract ourselves with things in the world instead of discovering tools to get better. For me, those tools were diving head first into therapy and doing

some hard work. It was also having a dog by my side for years. A dog that was constant in her love. She was steady and it's just what I needed. This book is a weaving story of how Maddie taught me to live wholeheartedly. At first, "lounging" might seem like a funny approach, but I'm not talking about being lazy or simply lying around. Maddie is the sort of dog who wants to run five miles every day, to sniff every smell, to fully engage with the world. And then after living fully, she can take pause and be present; take it slow and be content exactly where she is.

When I look through the photos in this book I see love songs to a wonderful dog who has been so devoted to me. Maddie is always up for an adventure, but she also reminds me to take it slow, to find comfort in strange places, to not be in such a hurry to see the next place. Just to lounge on something with good people. She doesn't care where we go, she just wants to go with me. She doesn't care what I drive. She's not worried about who I know or how well I did last year. The only thing Maddie wants is for me to lay with her in the grass and have no better place to be. To be right there, fully with her. That's why dogs are so special. What they demand from us is so simple: just our presence.

Theron Humphrey

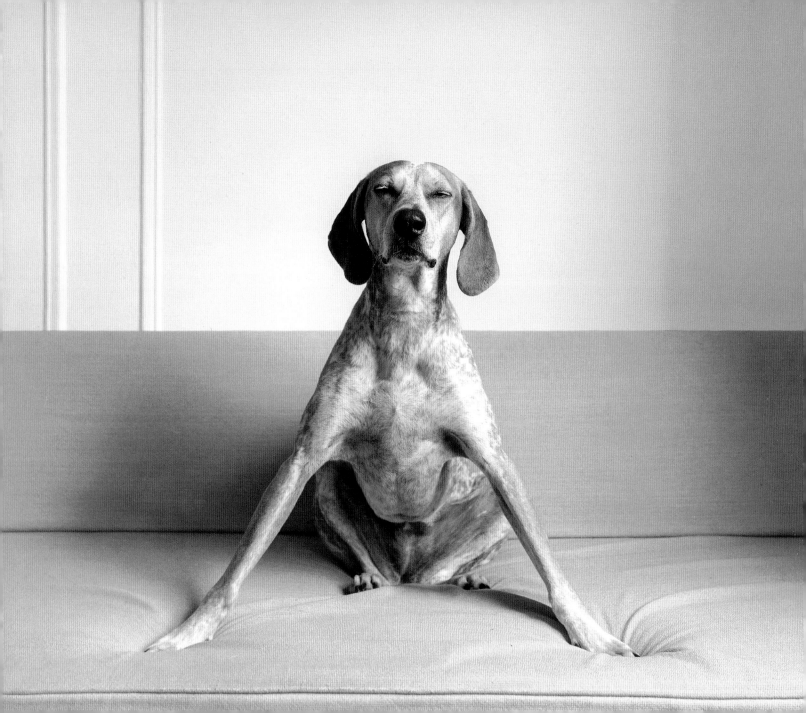

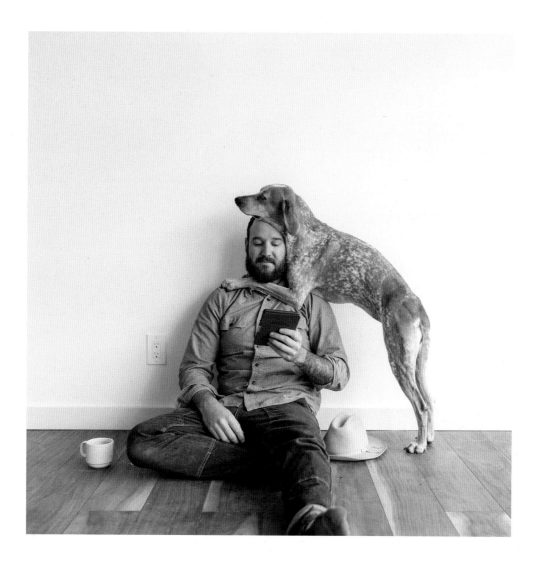

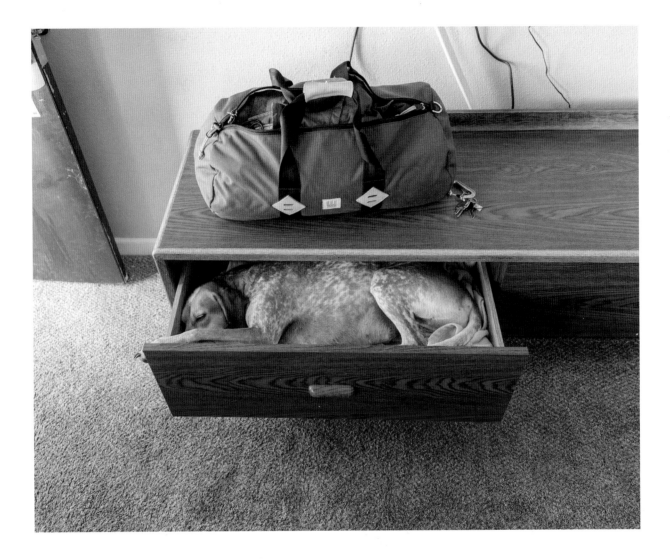

Billings, MT ⟶ Dripping Springs, TX

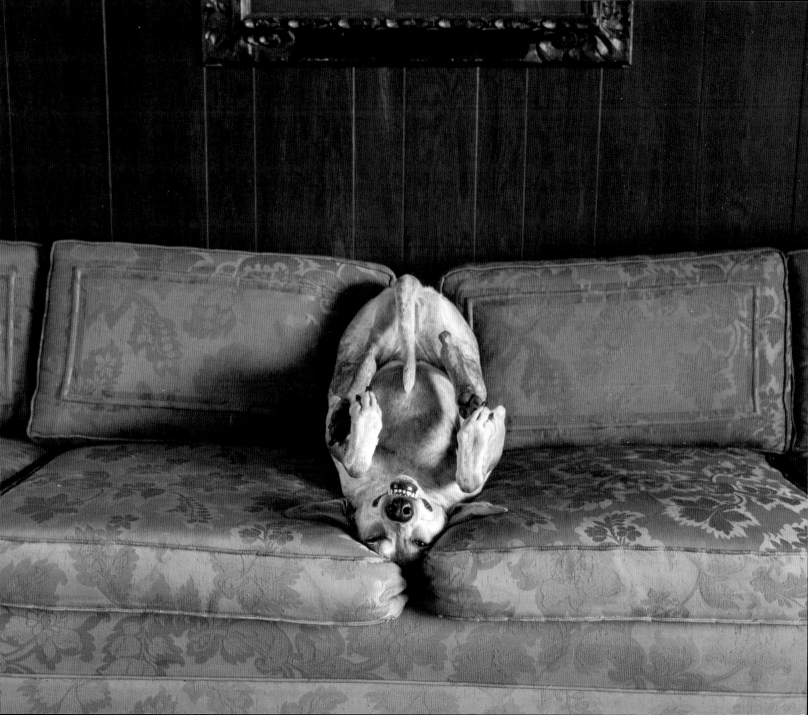

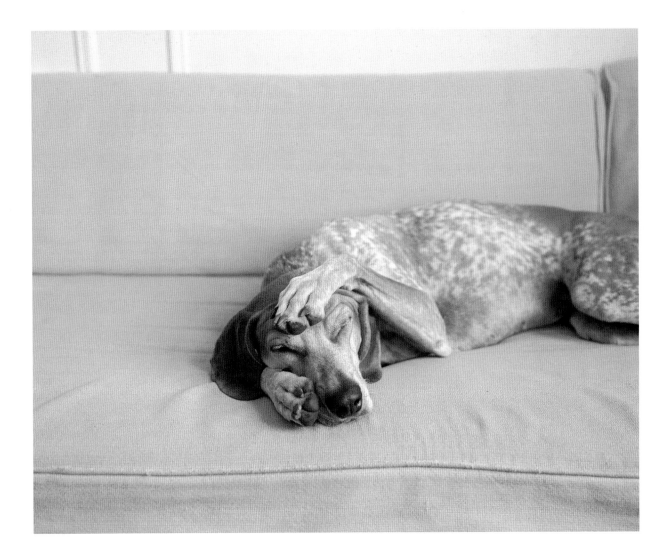

12 Brooklyn, NY

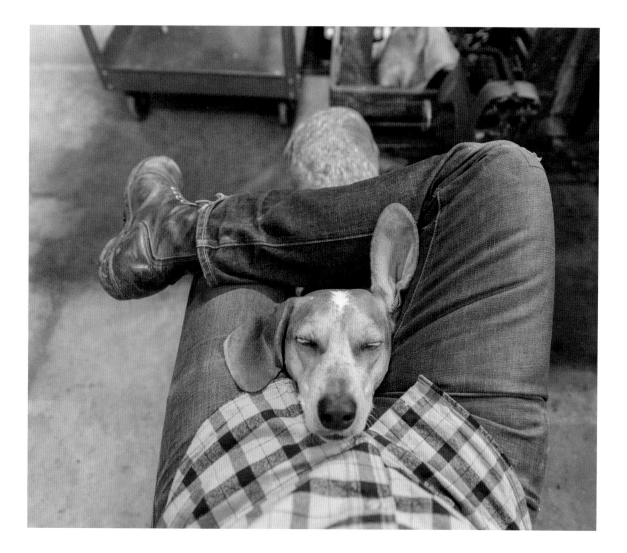

Fort Houston / Nashville, TN 13

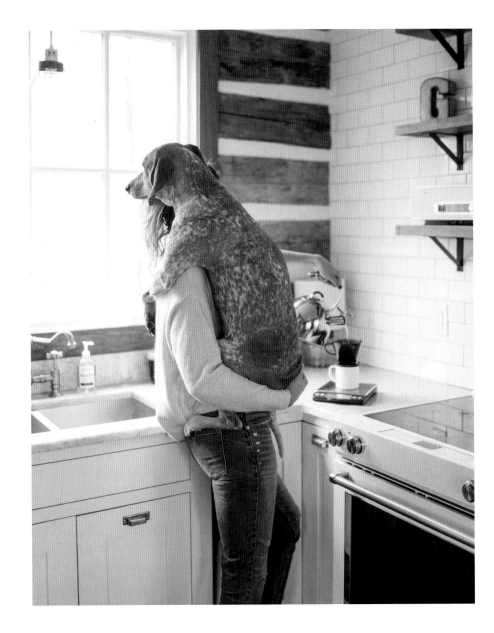

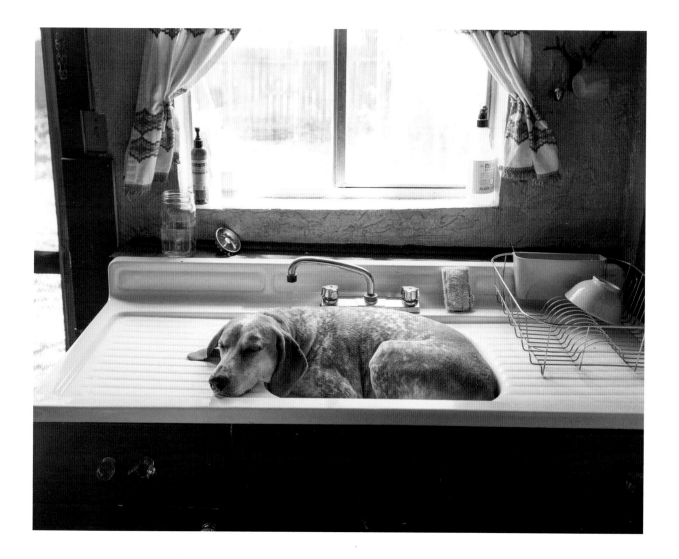

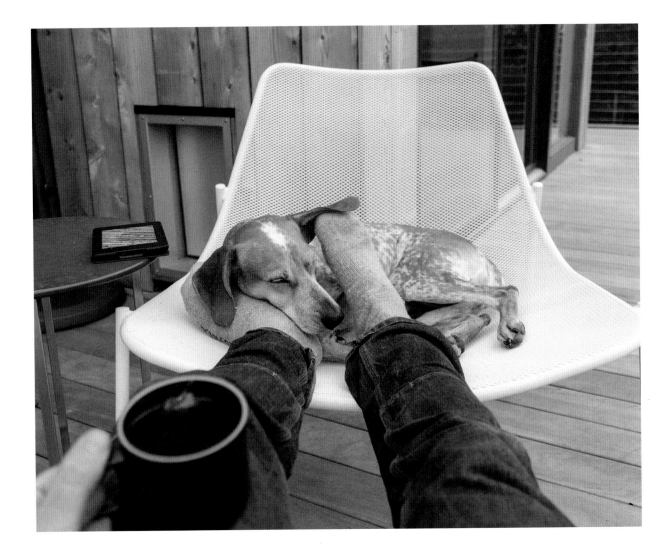

Front porch life / Nashville, TN

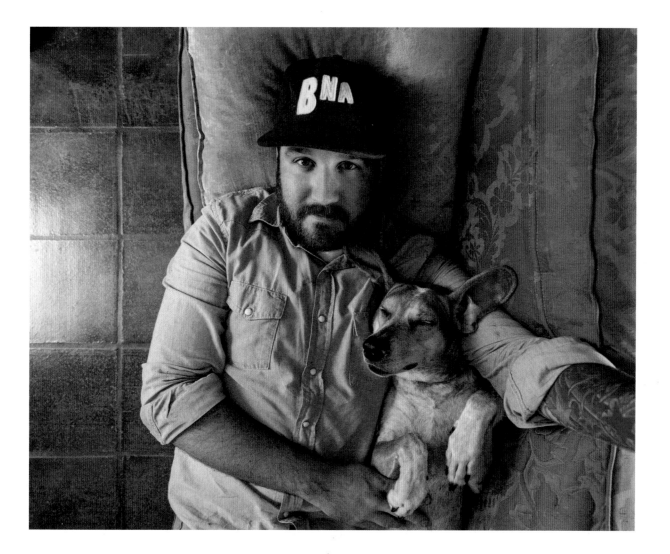

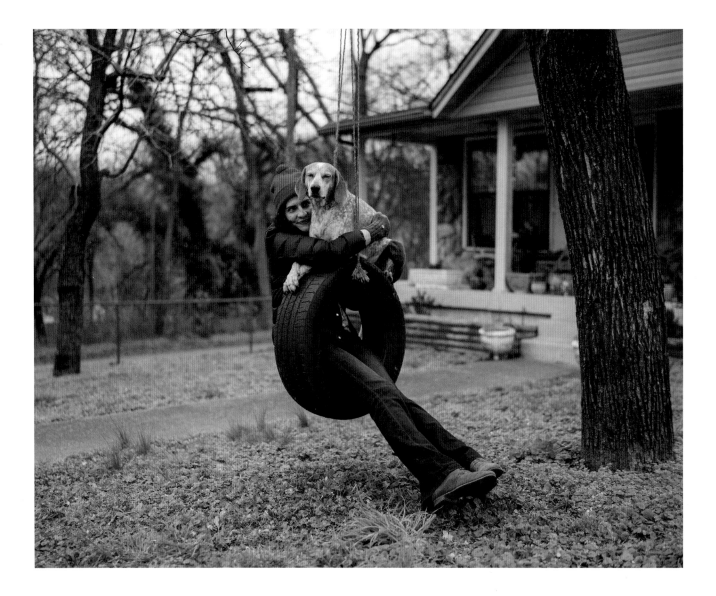

Auntie Ruthie / Nashville, TN

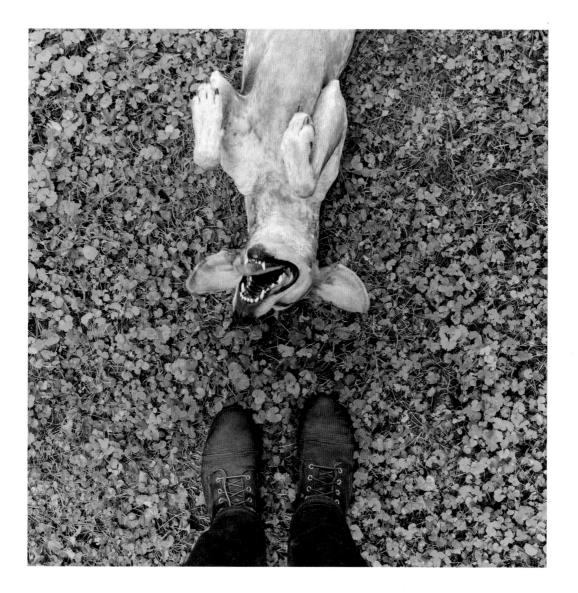

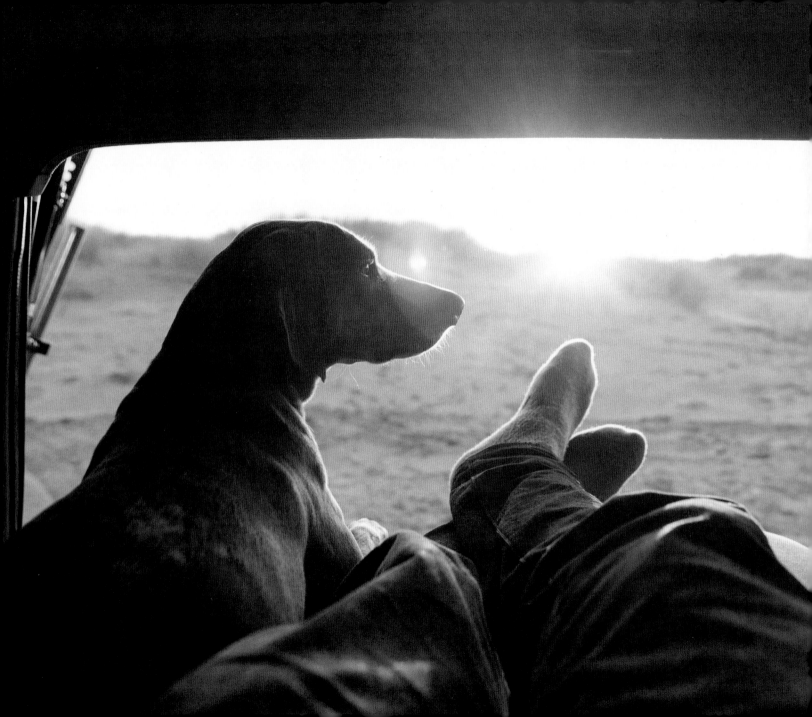

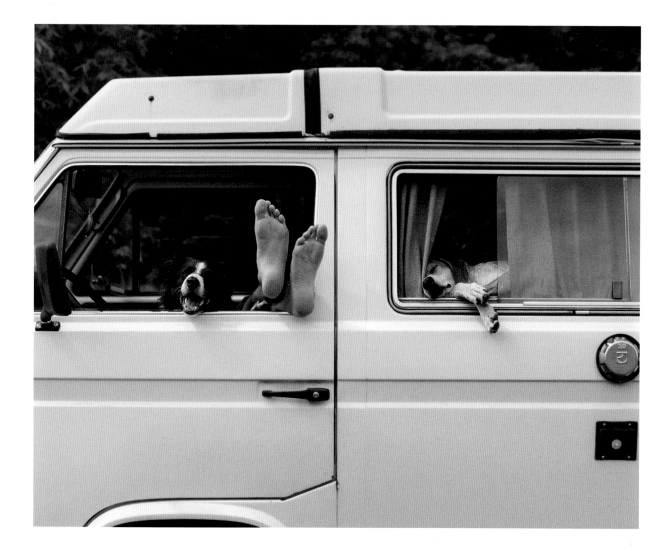

Momo & Maddie / Nashville, TN

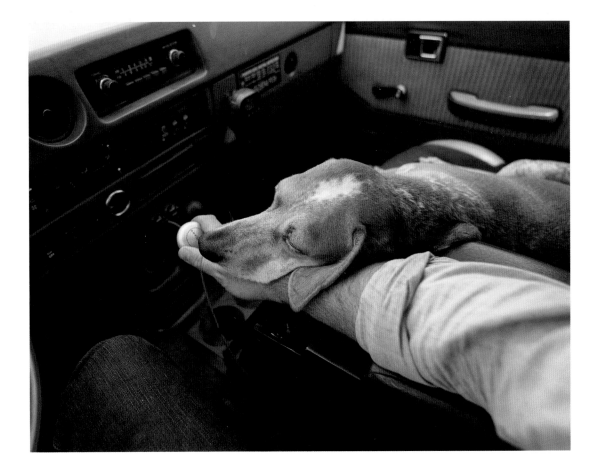

↗ Somewhere out on the road, USA

→ **Kaniksu National Forest** / Sandpoint, ID

Sandpoint is a wonderful slice of the world up in the Idaho Panhandle. It's a whole bunch of mountains and snow, and it has one of the deeper lakes around. I hung my hat there for a few years and learned a whole bunch about photography at a commercial studio. It was the town I took off from with a broken heart years ago. These days I try to make it back once a year. It's sort of like I have a redemption story with the place. If Jeff Strauss, the photo studio manager, ever comes across this little caption I'd like to tell him I'm grateful for him believing in me along the way and giving me good work that brought me right here today.

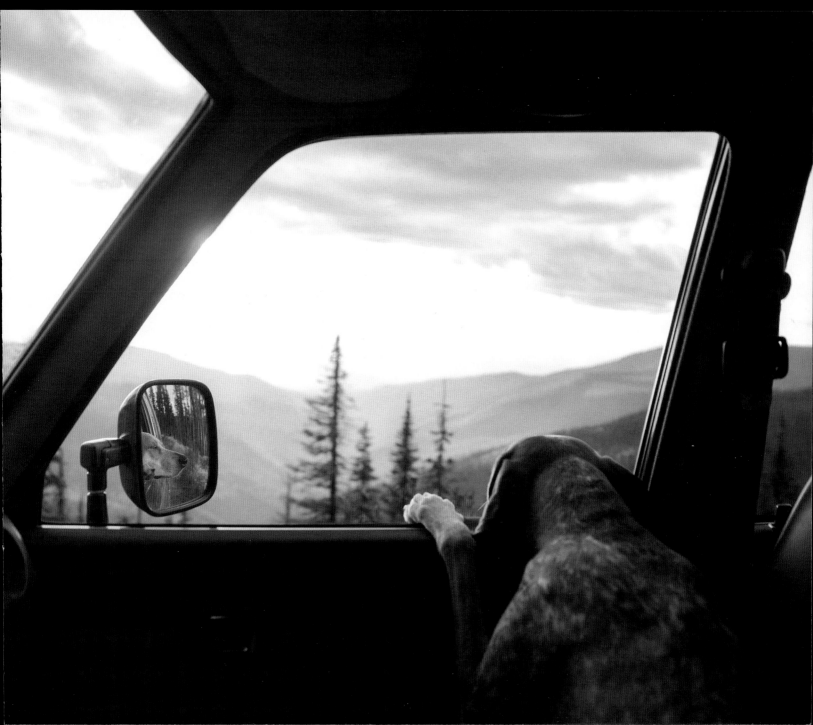

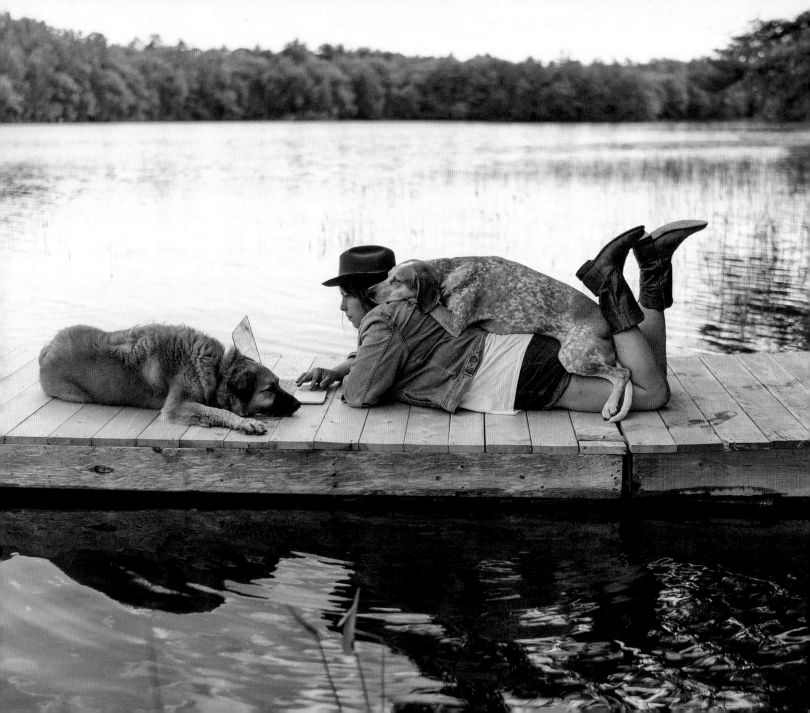

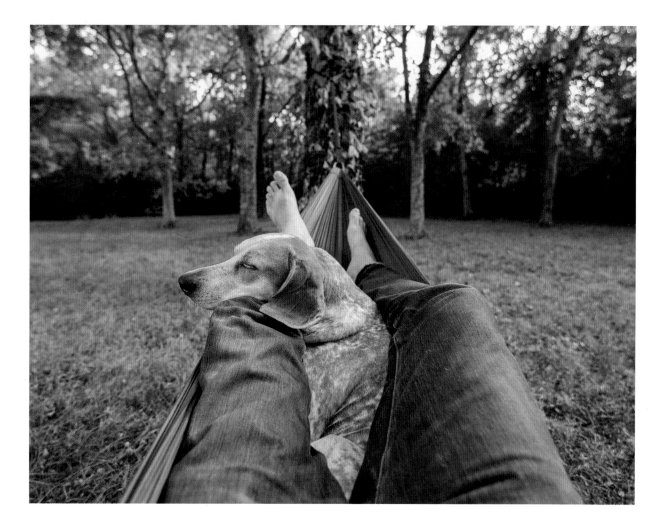

← **Emily, Eleanor, and Maddie** / Nobleboro, ME

↘ **My backyard** / Nashville, TN

I took this image right in my backyard, on my little one-acre slice. After spending years wandering around the United States it feels right to have my own land to walk on. I never thought that my first home would be something I built. But after working on it for a year, it's hard to imagine any other way. I'm grateful that I get to look out and see these trees and live among them.

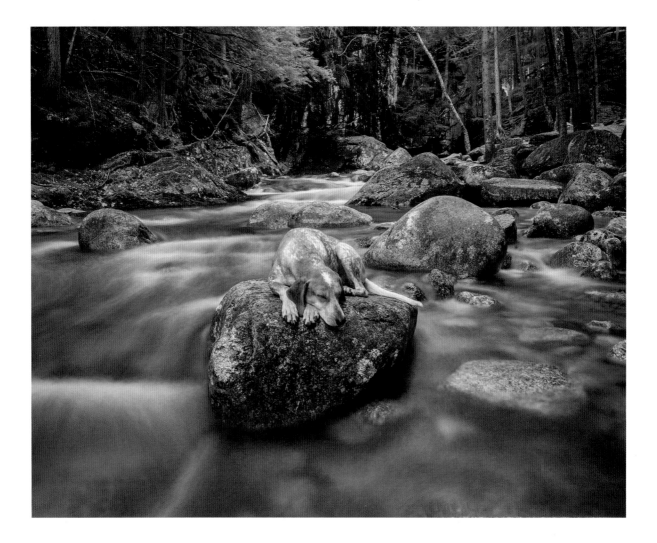

↗ **White River National Forest** / Glenwood Springs, CO

I've hiked through these mountains a fair bit over the years. I always seem to end up far north when it's into fall and quiet. This image came about after a hike to a waterfall, when I sat down to look at the river. When you stare at something that's moving long enough it all starts to blur in a really nice way. So Maddie and I hopped on the rocks and I shot this sixty-second exposure with my tripod.

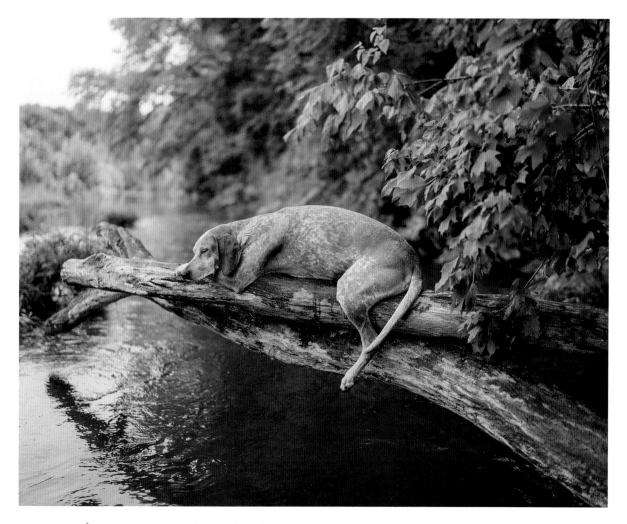

⬉ Primm Springs, TN

This is my favorite swimming hole outside of Nashville. I've camped out here many a night under the stars, cooking meals with dear friends. I found this spot when I was wandering around the countryside like I often do. One Sunday afternoon I was parked on the edge of a field and some nice folks stopped and asked if I needed any help. Turns out it was their land I was standing on. Since then I've been friends with the Allens and often head out their way to enjoy their farm. I love it out there.

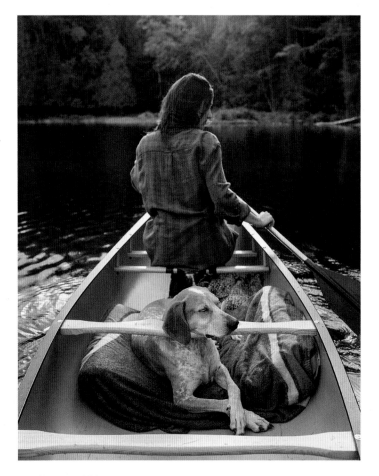

↗ Saranac, NY

→ Denmark, ME

I spent a month on this pond in the fall of 2015. The cabin was right on the water's edge, with a quintessential dock and all. I stacked a cord of wood and burned it in the stove that was right in the middle of the A-frame. I didn't go there so much to be alone, but just to spend time somewhere that was so close to nature. A place where you could look out the window and see only water and trees. I'm real fond of that place because I read Donald Miller's *Scary Close* in that cabin. That book is a game changer.

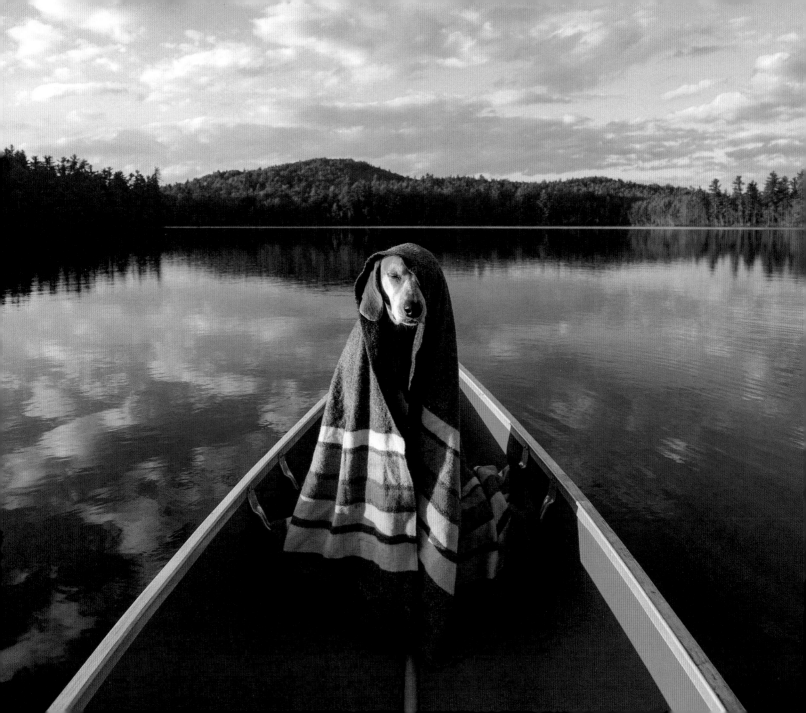

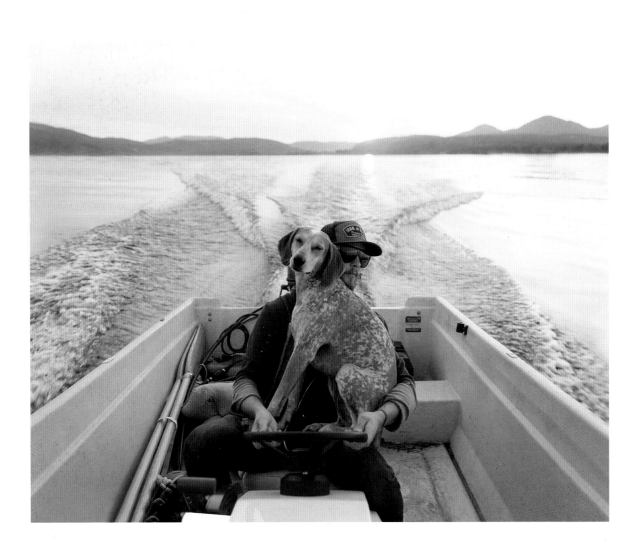

Uncle Josh / Sandpoint, ID

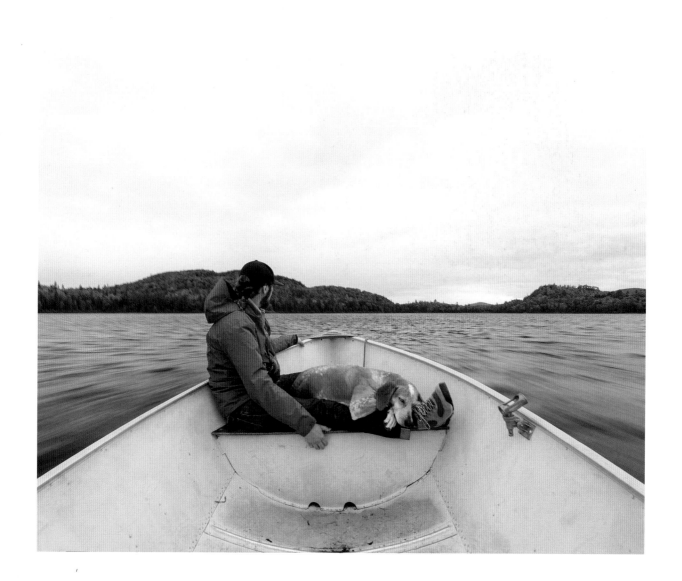

Ashland, ME

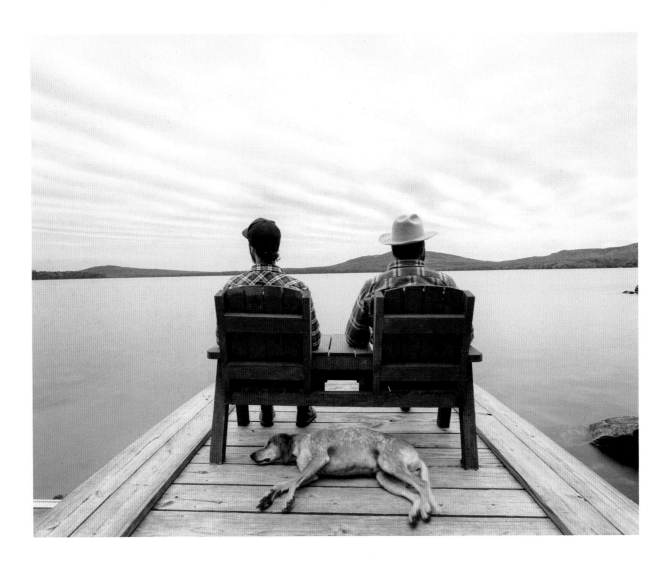

Josh, Maddie, and Me / Sullivan, ME

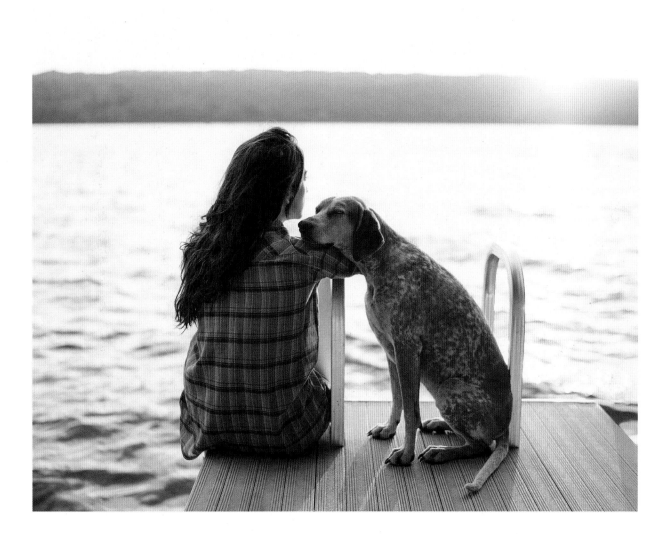

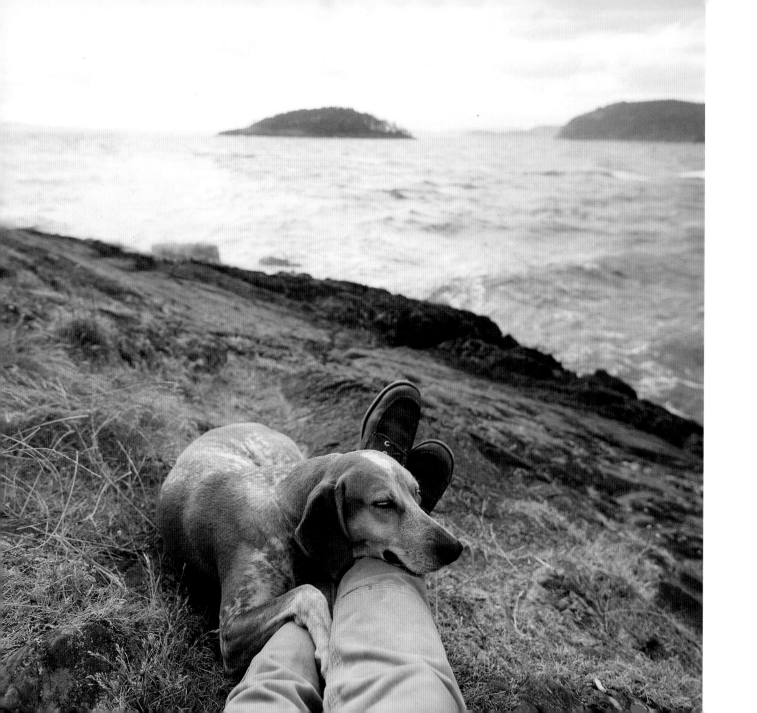

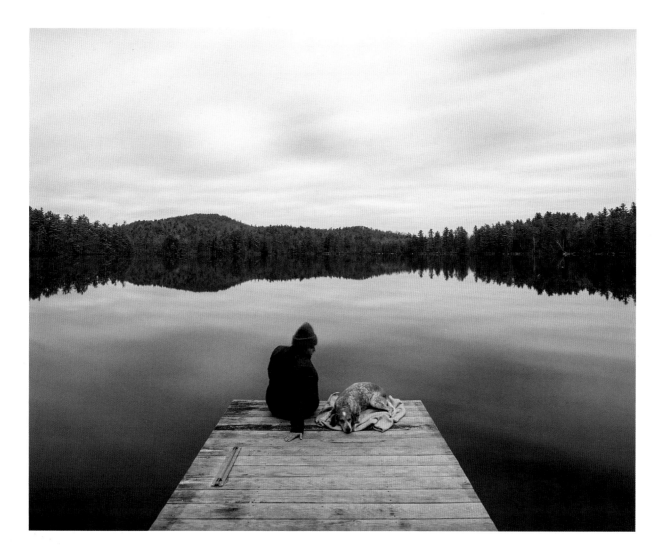

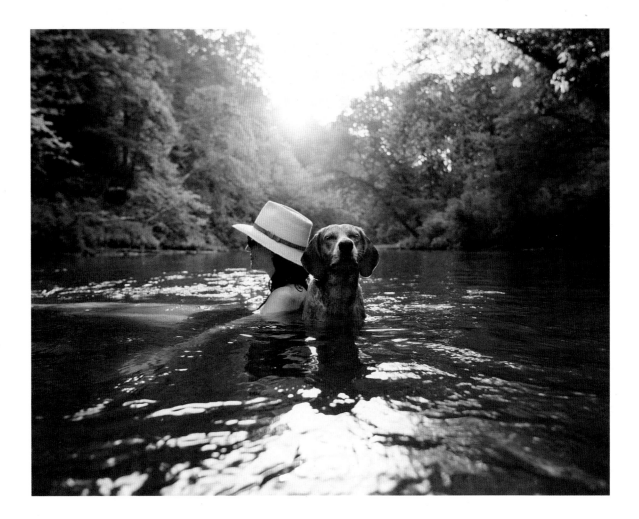

↗ **Ruthie** / Franklin, TN

→ **Max** / Leadville, CO

My favorite place to be is up in the mountains. Ever since I was a little kid I've found a deep peace being outside. I suppose I'm really lucky that Maddie and my friends often join me out there. Max and I once took off for a week-long adventure up in the Rocky Mountains toward the end of summer. He's become such a good friend in this season of life. Grateful he's the sort of friend that will go camping and live out of a truck in the backcountry for a week.

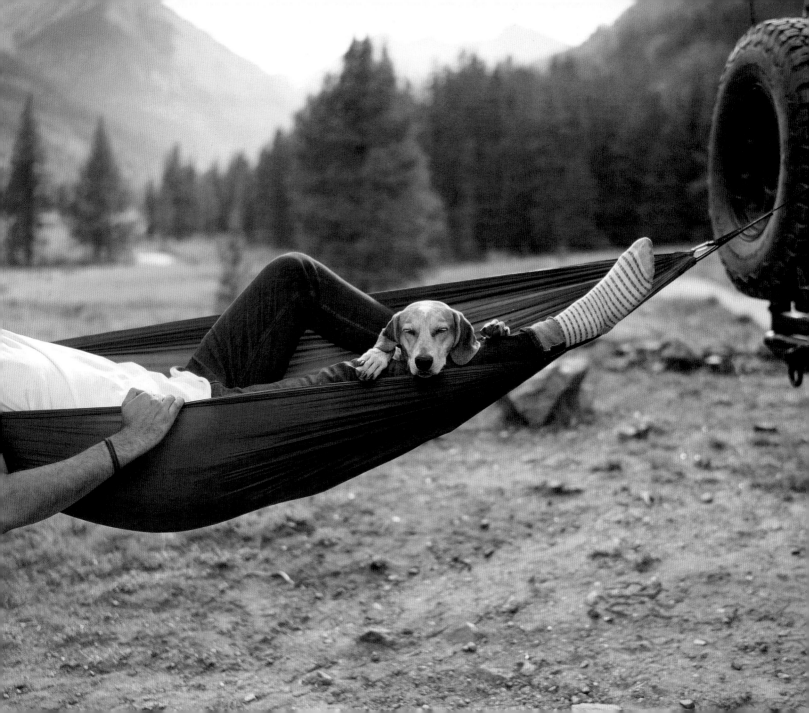

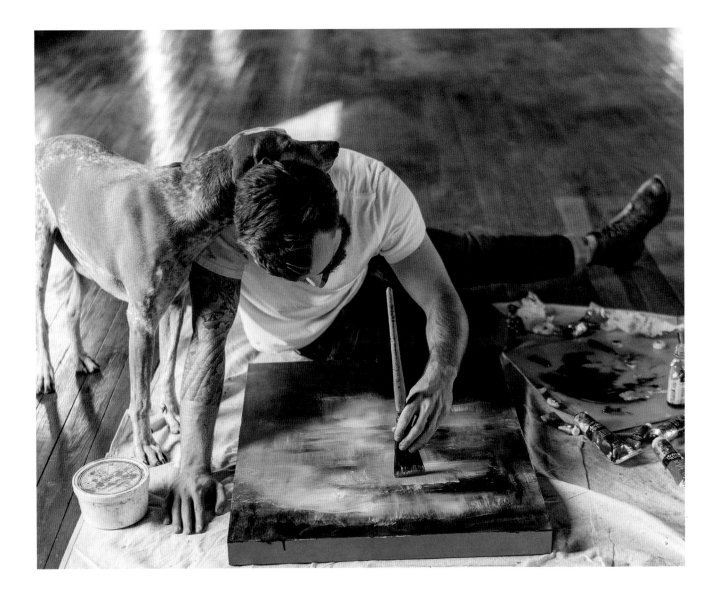

38 ↗ **Shane** / Nashville, TN

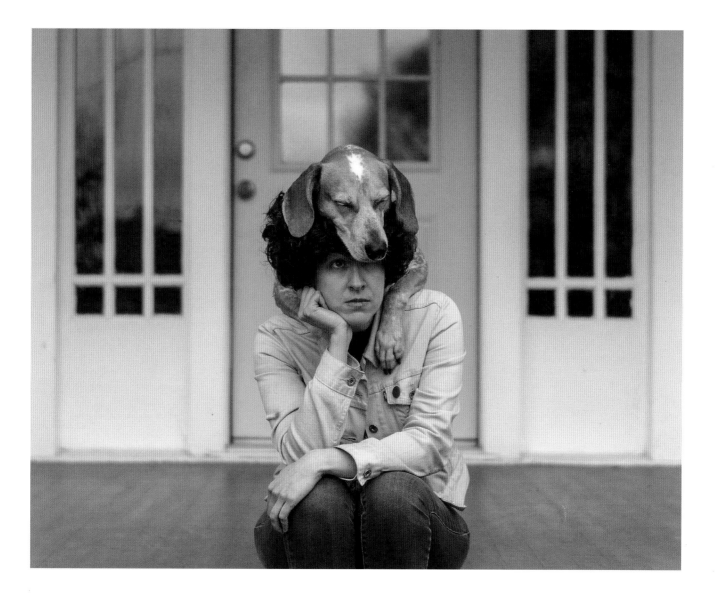

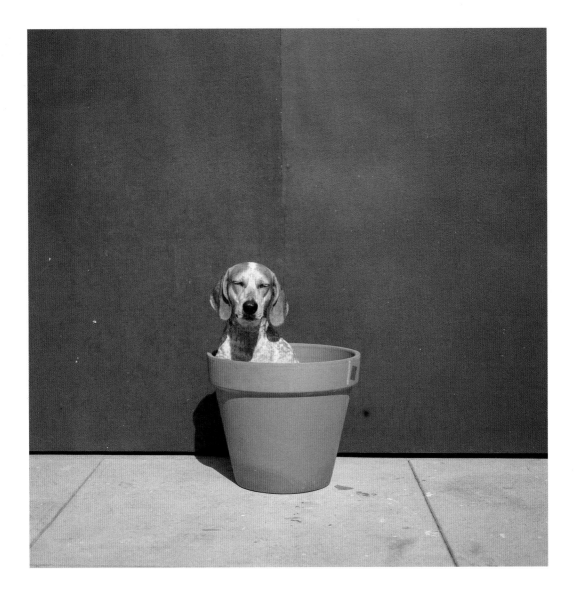

Los Angeles, CA

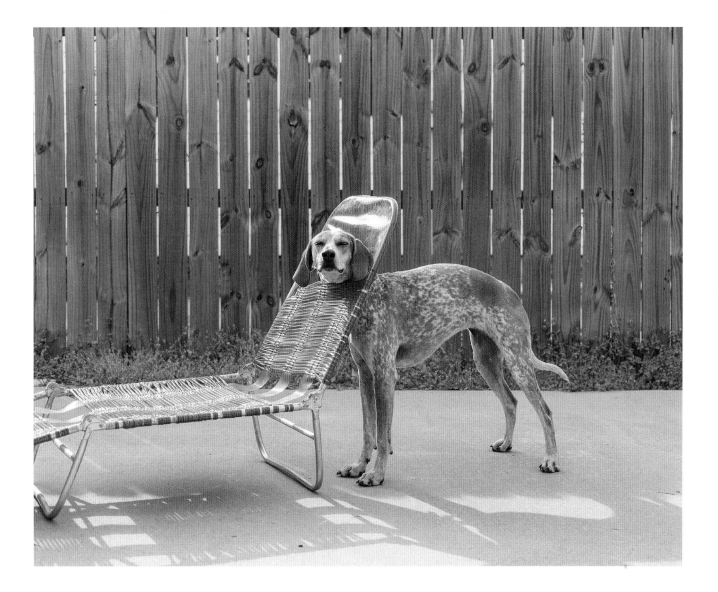

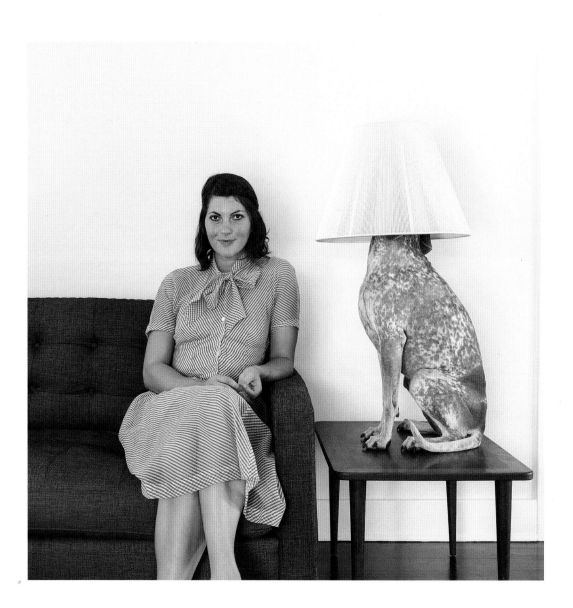

Carla / Los Angeles, CA

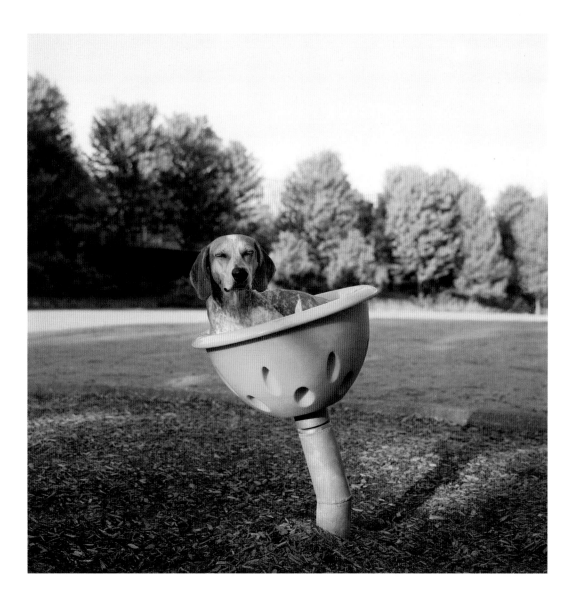

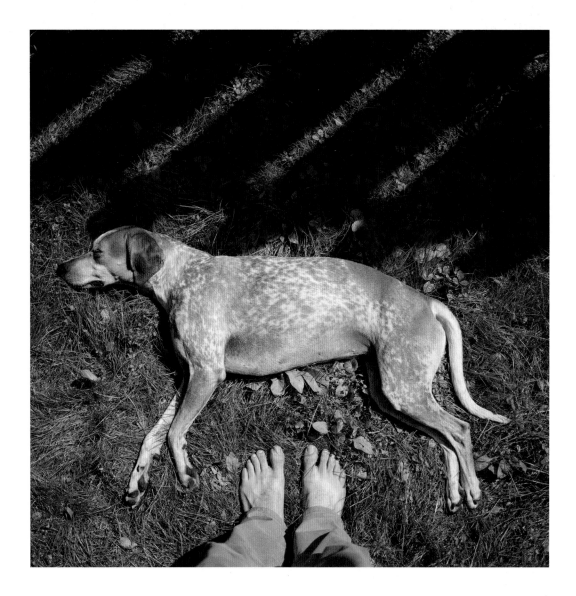

⬈ Atlanta, GA → Dripping Springs, TX

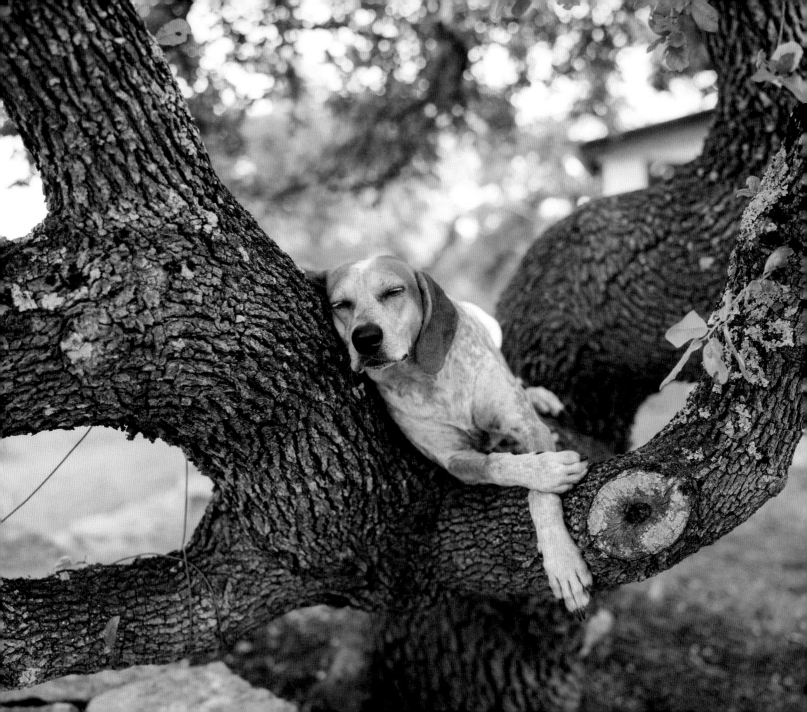

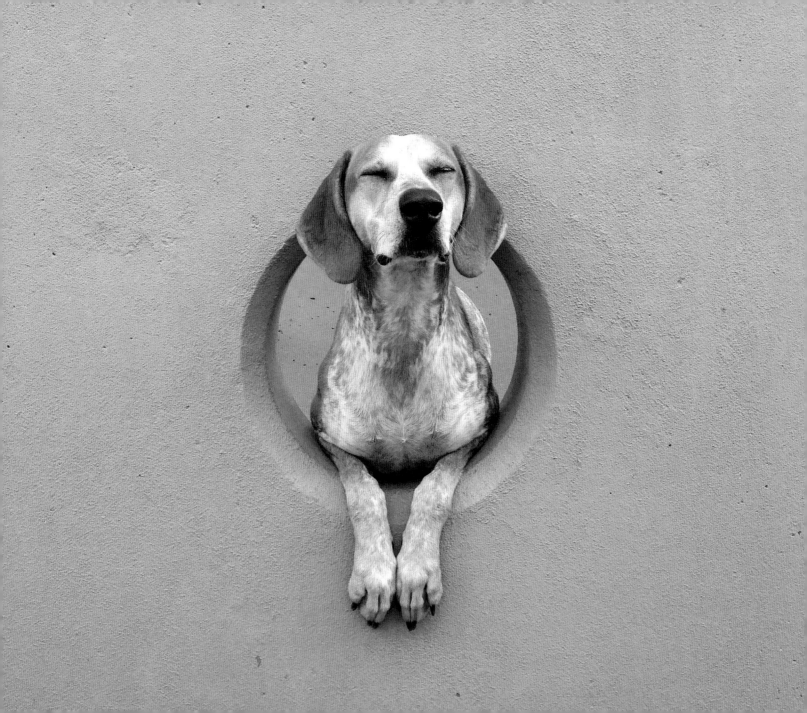

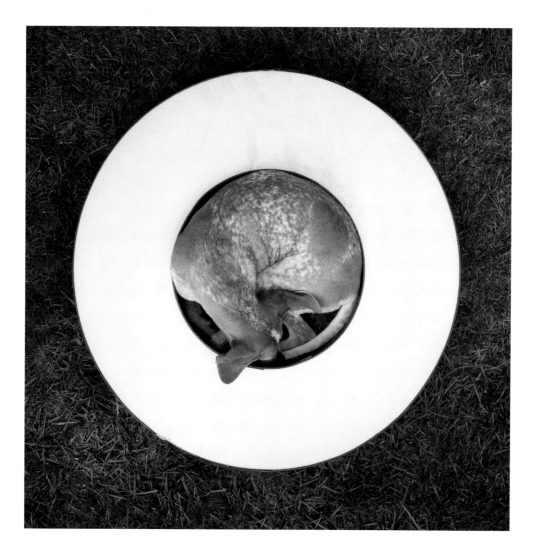

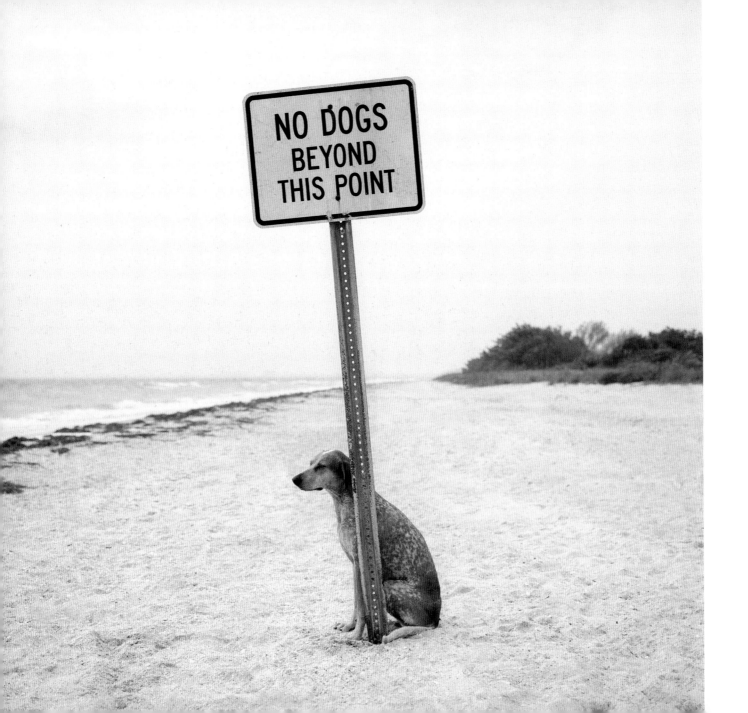

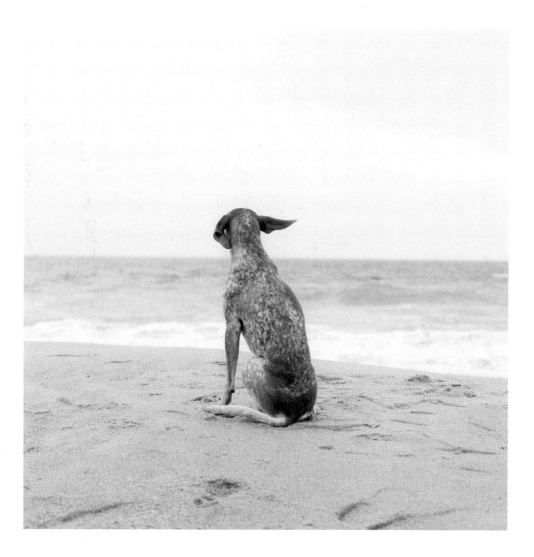

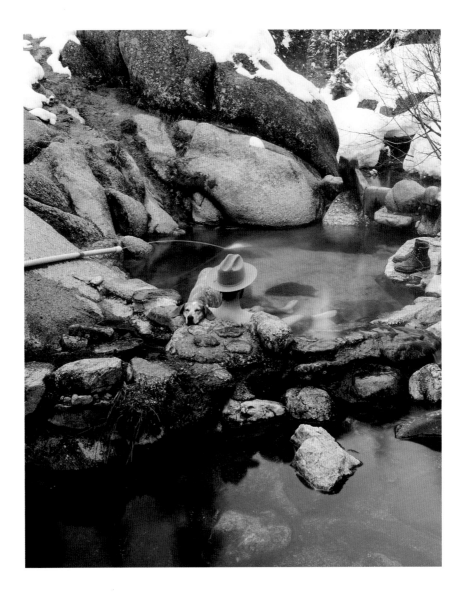

McCall, ID

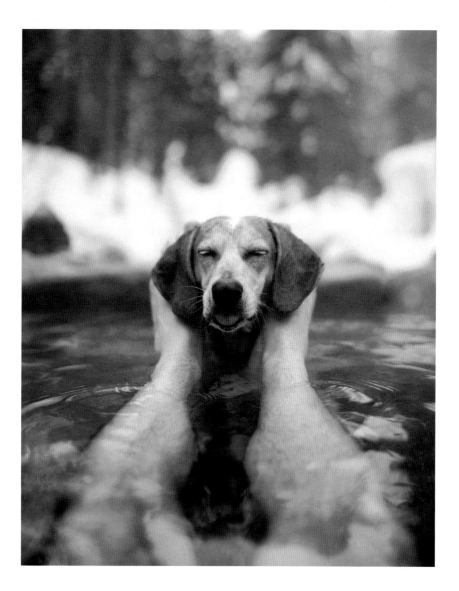

McCall, ID

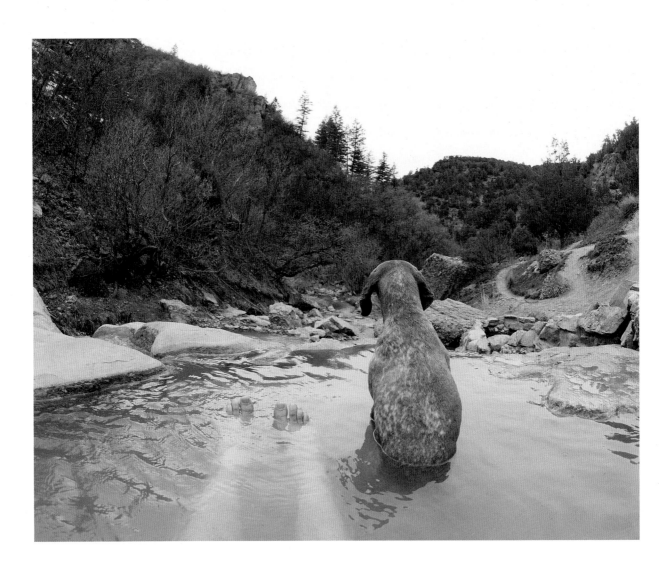

↗ → **Fifth Water Hot Springs** / Springville, UT

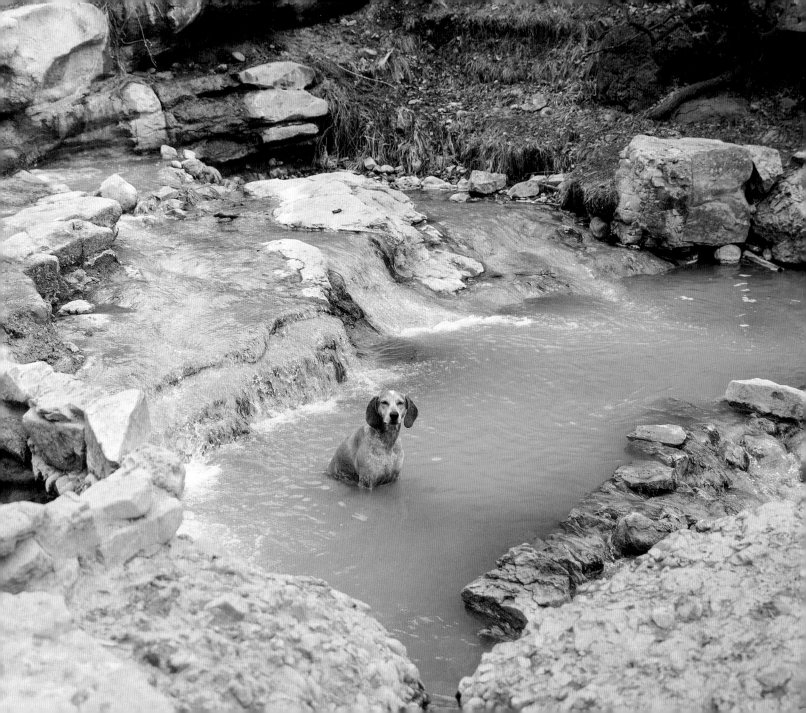

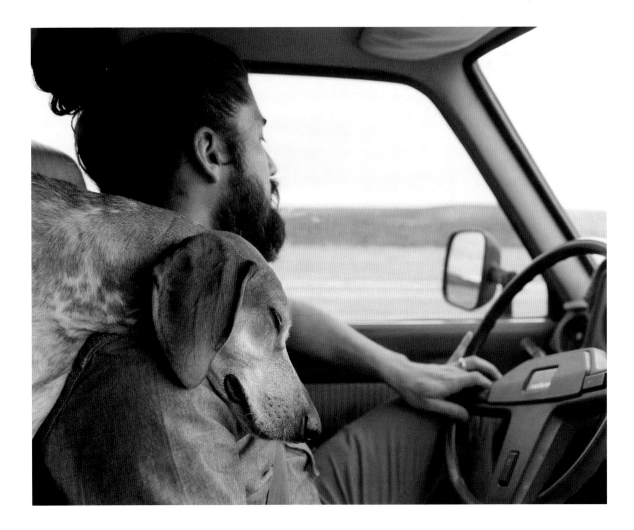

✎ **Noe G** / Interstate 10, TX

→ South Dakota, USA

It takes a bit longer, but if you aren't in a hurry it's hard to deny that small roads are the best way to really see America. The scale of the world just feels right when you're not zipping by at seventy-five miles per hour. On the small roads there's the opportunity to see how folks are really living and what makes their places home. Nothing too unique about that idea, but I really am grateful for little backroad gems.

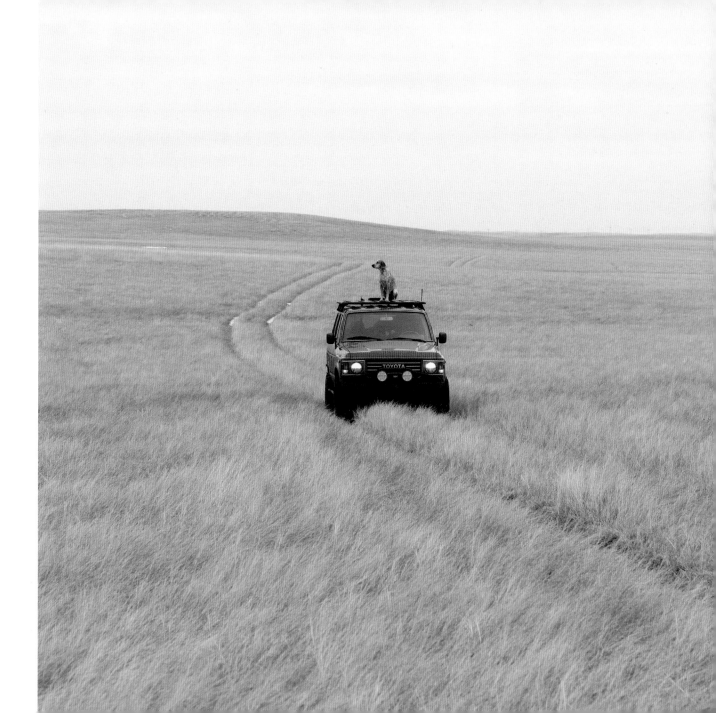

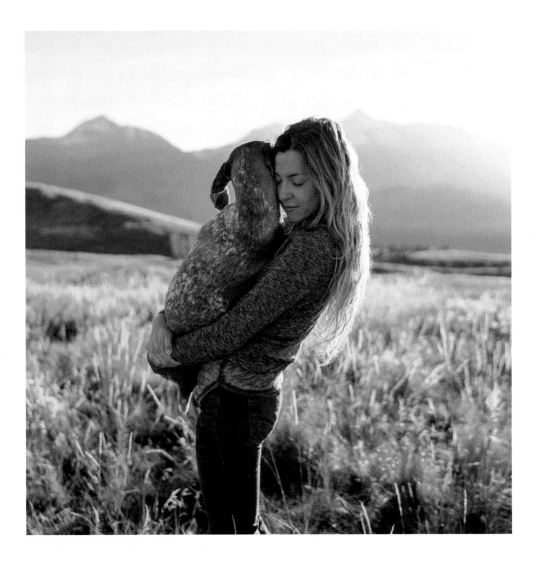

Tiffany / Telluride, CO

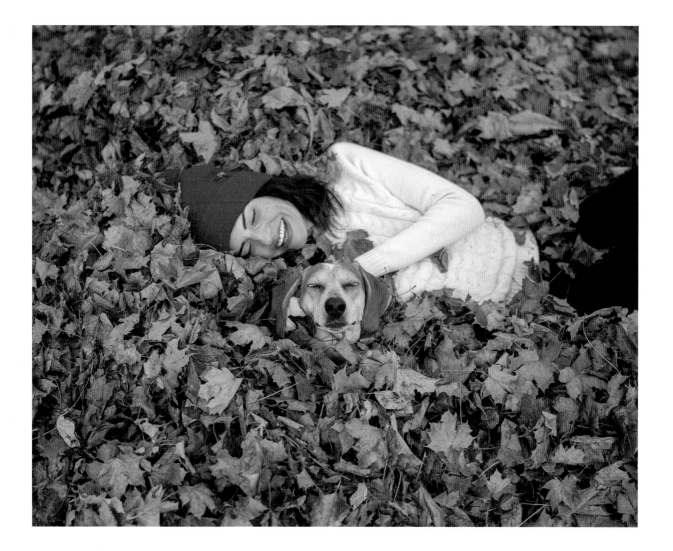

Ruthie / Bar Harbor, ME

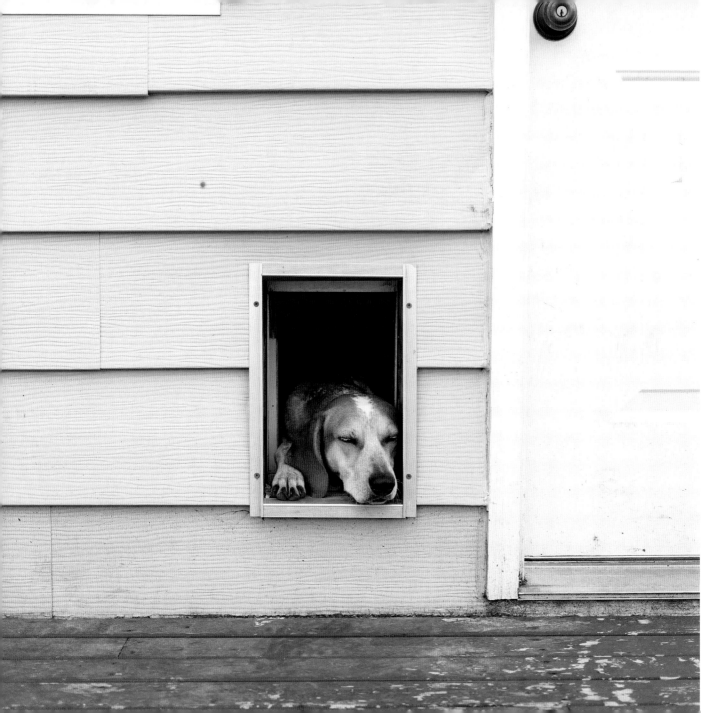

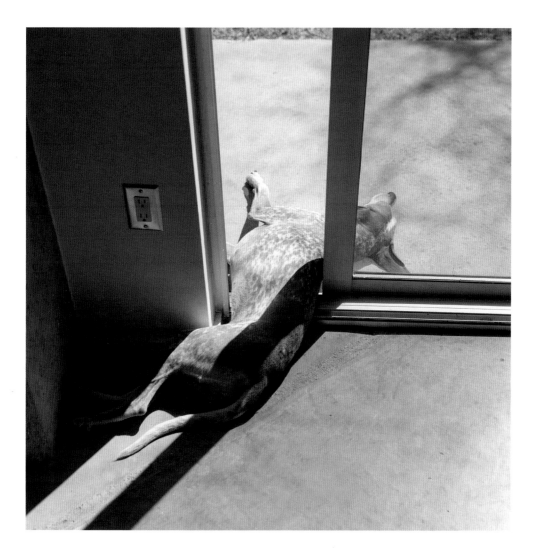

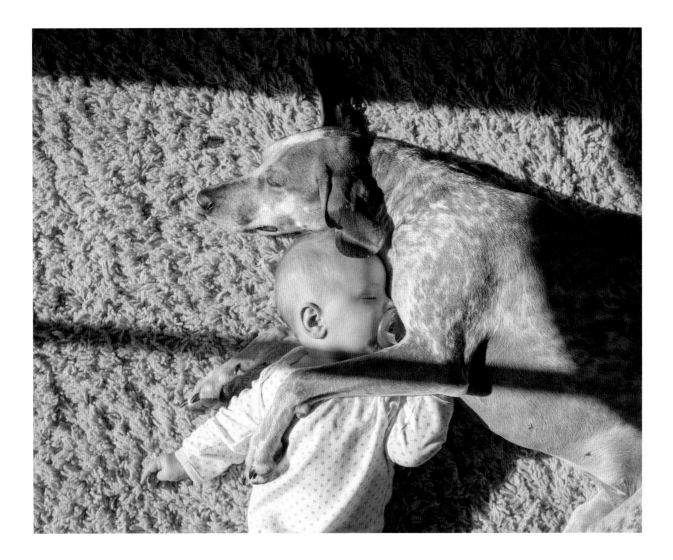

✎ **Max** / Atlanta, GA

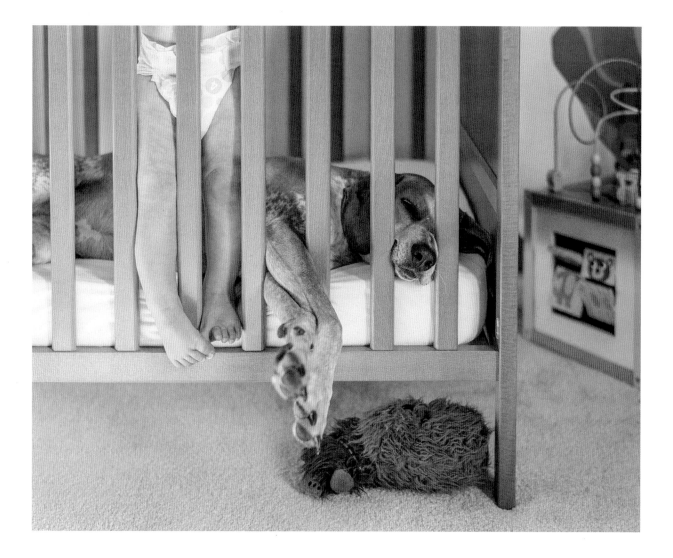

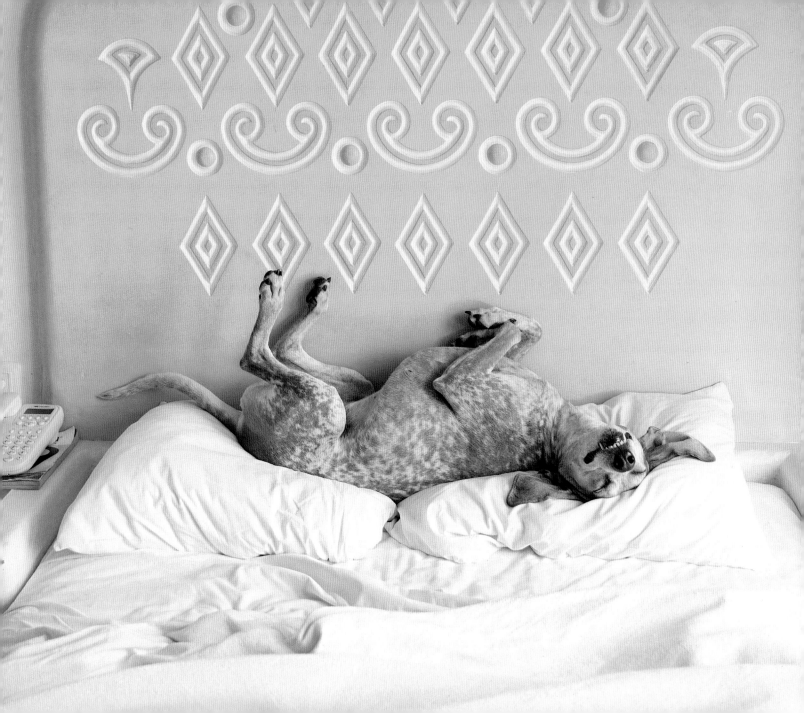

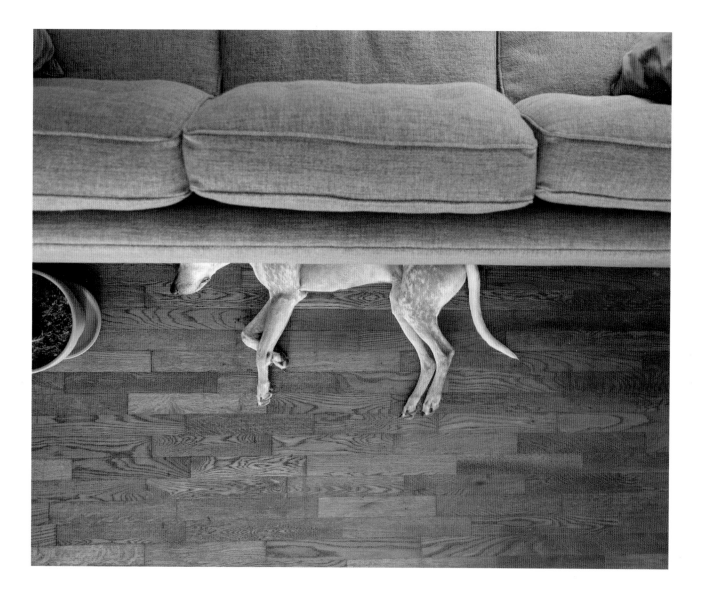

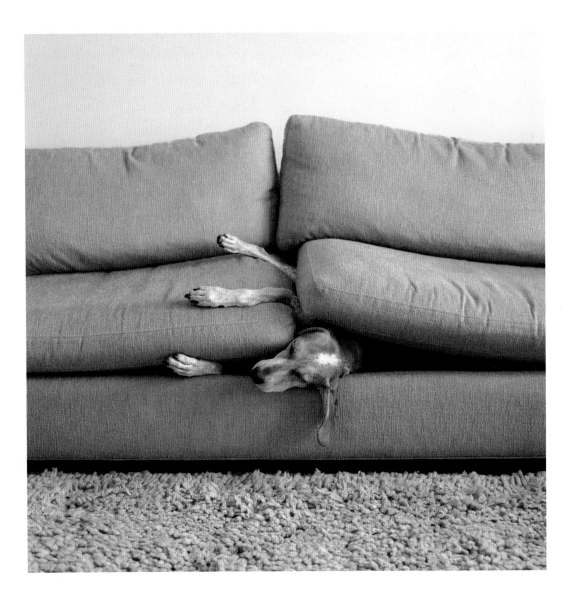

San Francisco, CA

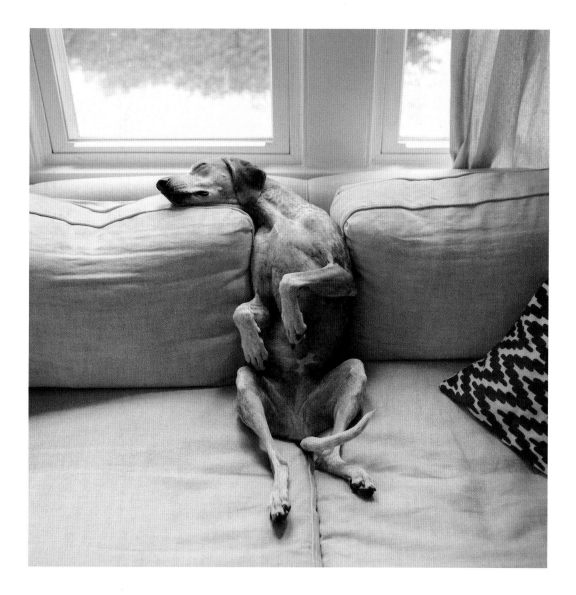

Nashville, TN

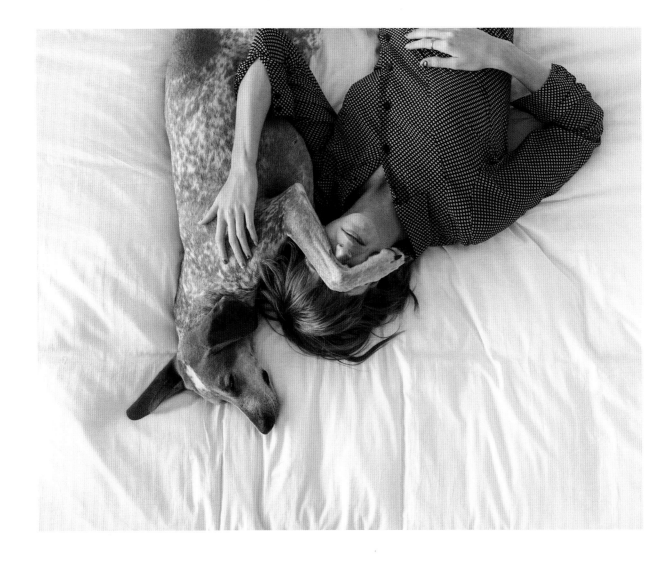

↗ **Amanda** / Brooklyn, NY

⟶ **Miles** / Carol Stream, IL

My little nephew Miles, my sister's first child. Sometimes I wish I could shrink down this small and curl up on Maddie, too.

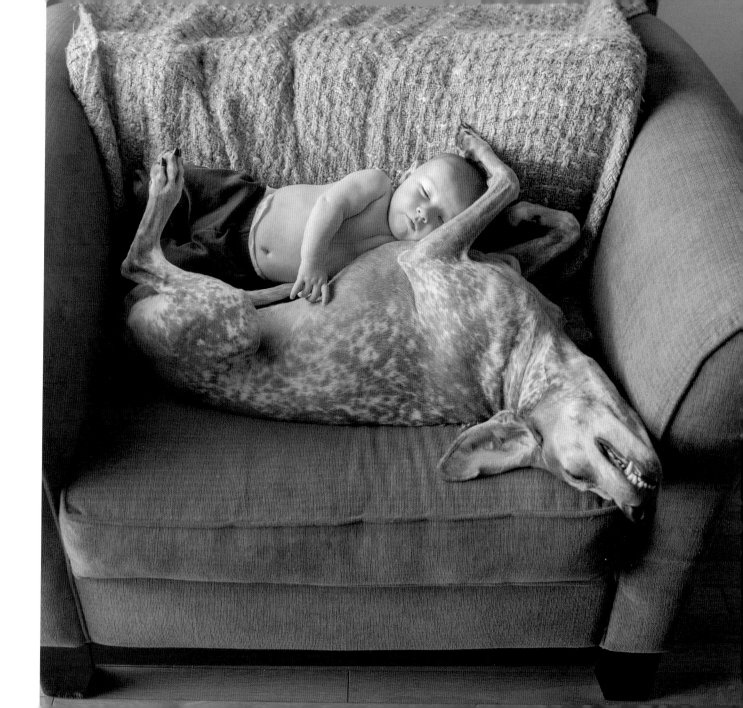

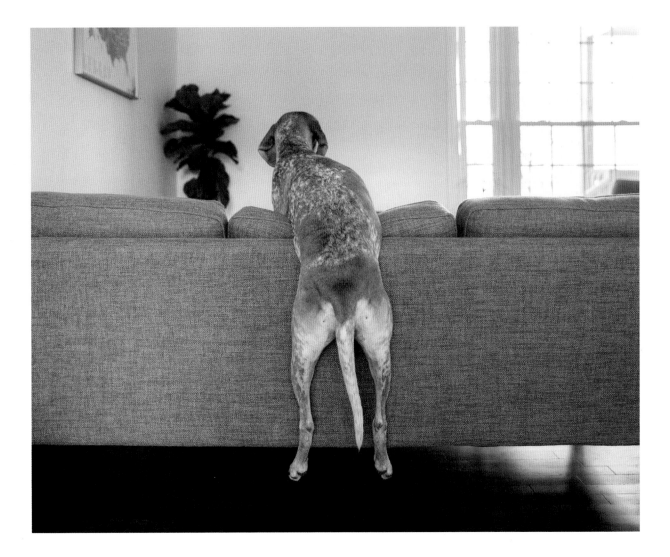

↗ Nashville, TN

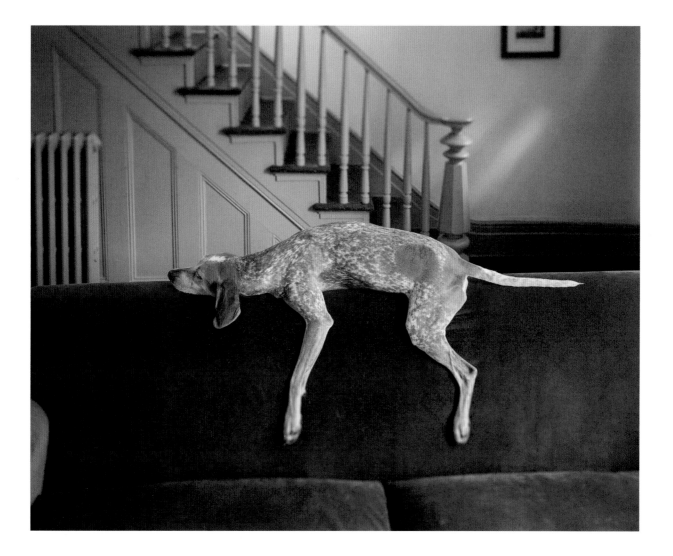

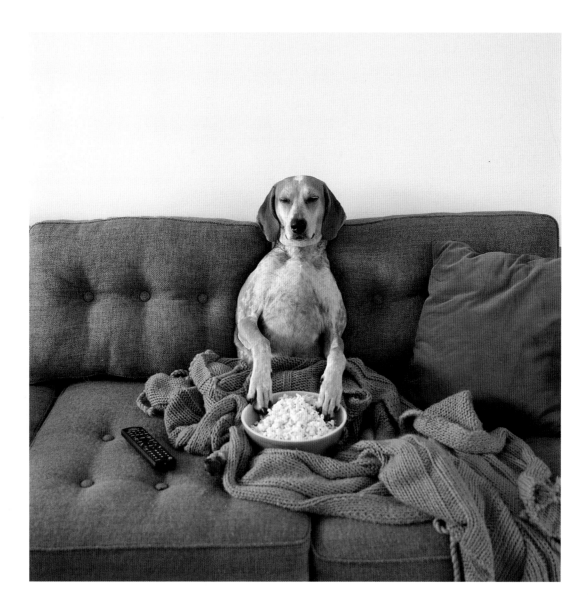

Nashville, TN

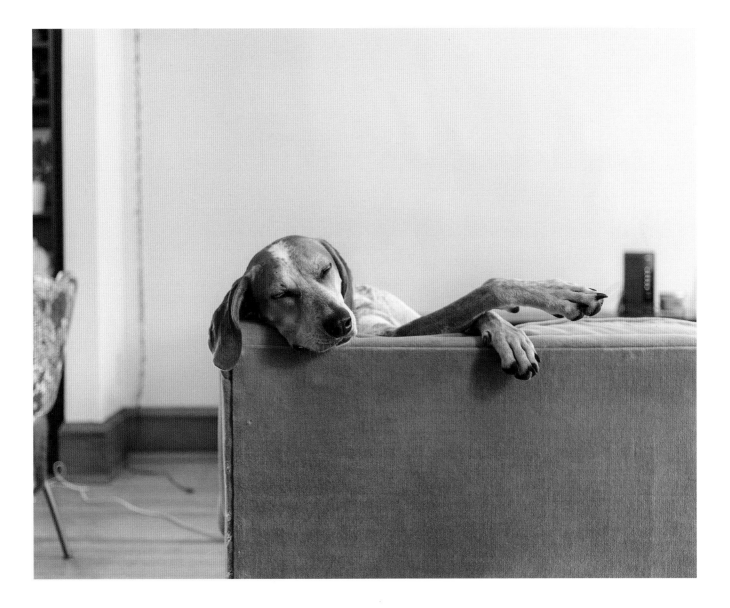

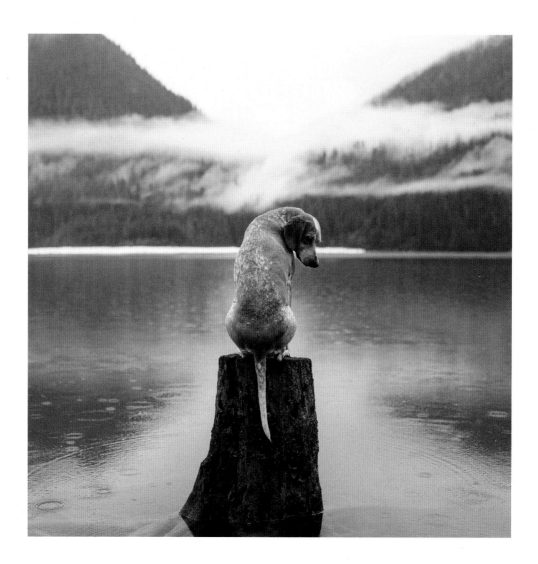

↗ Baker Lake, WA ⟶ **San Francisco–Oakland Bay Bridge** / San Francisco, CA

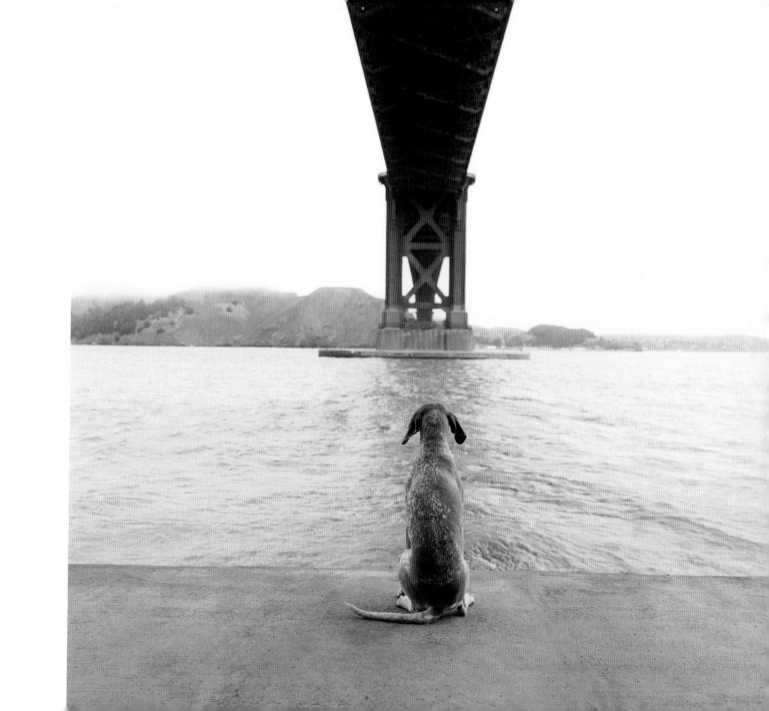

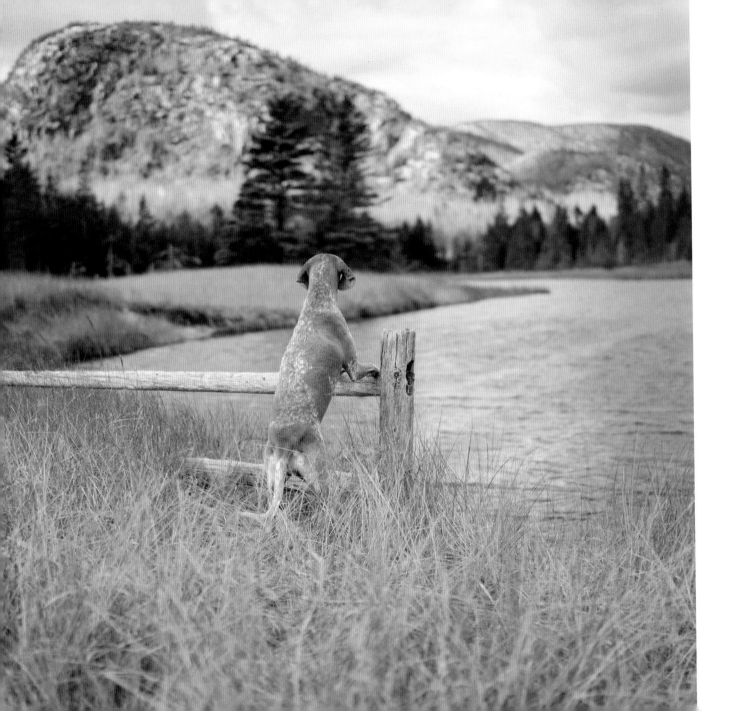

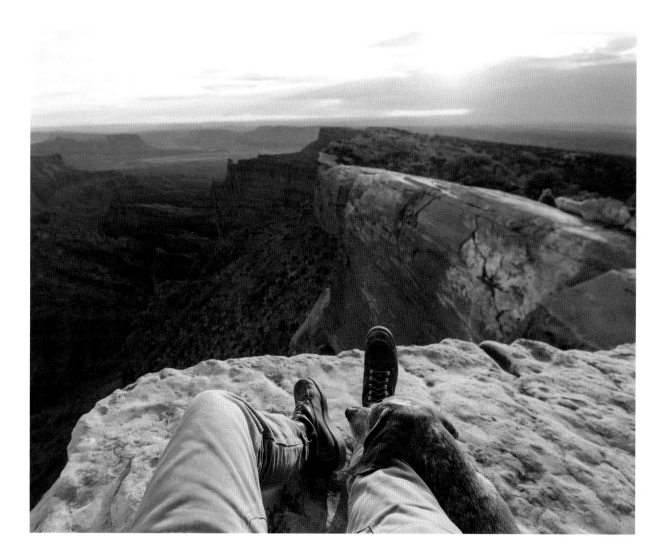

← Bar Harbor, ME

↖ **Top of the World** / Moab, UT

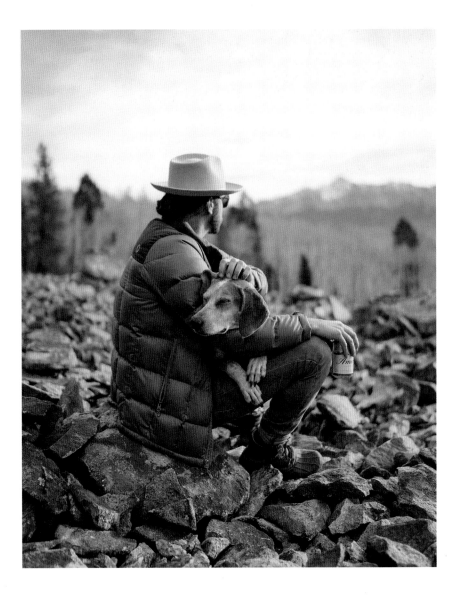

↗ **LaRue** / Telluride, CO → **Goblin Valley State Park** / Green River, UT

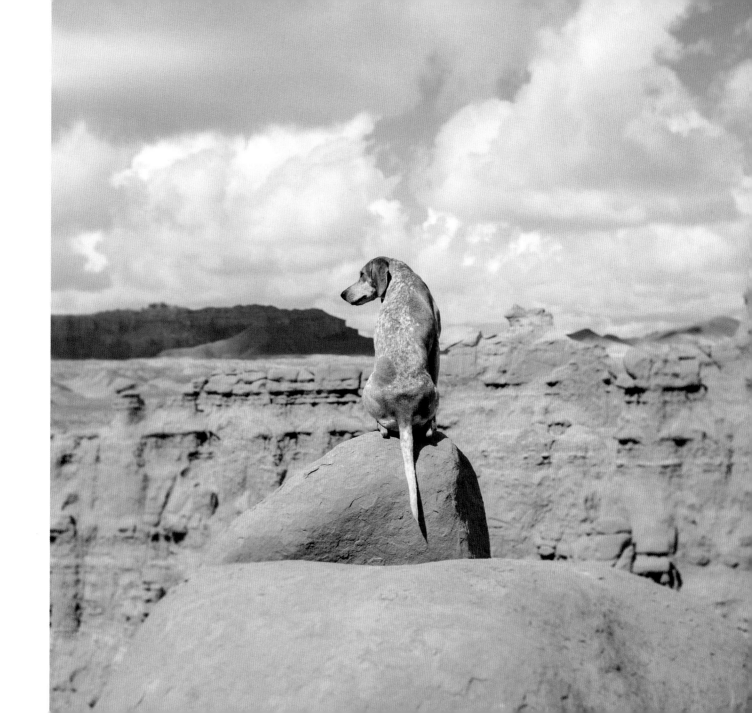

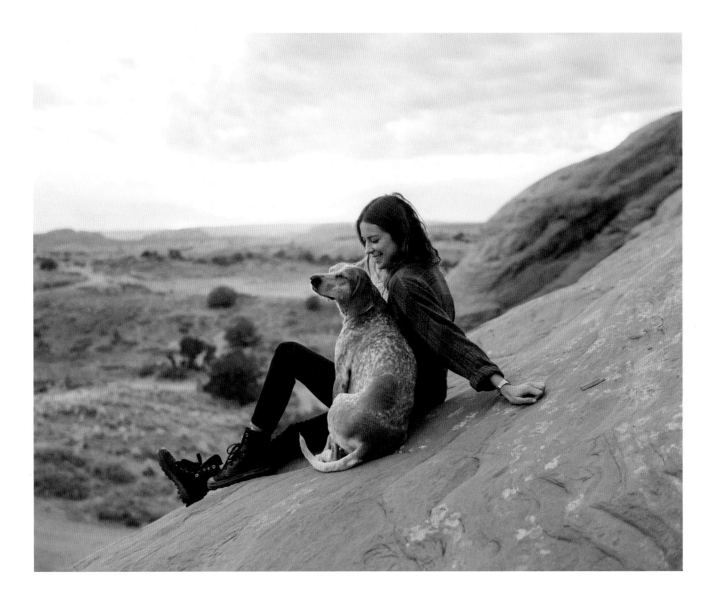

Pap / Moab, UT

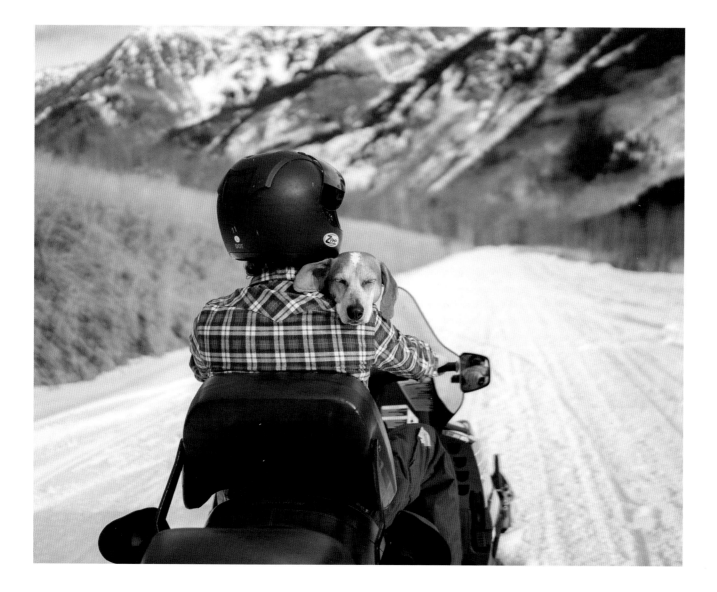

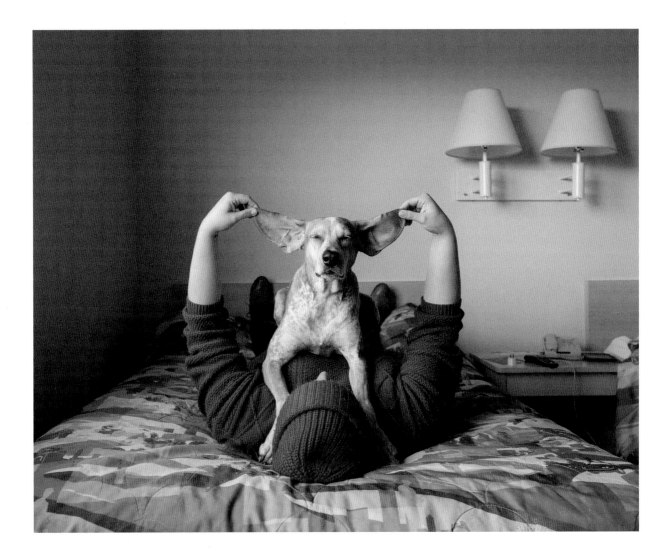

Emily / Boise, ID

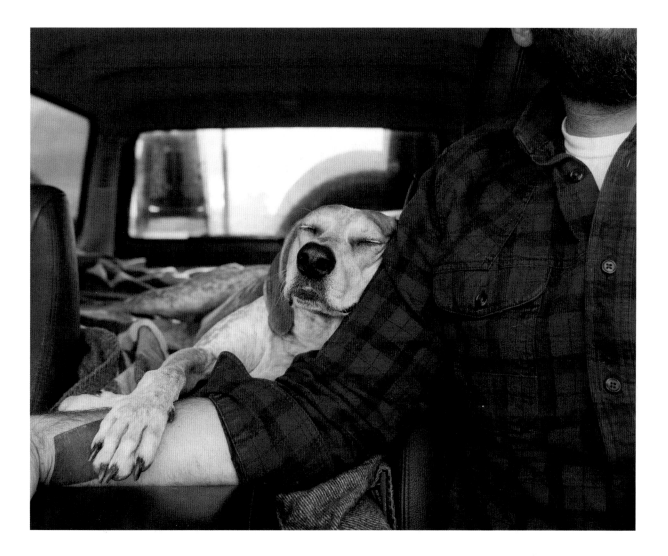

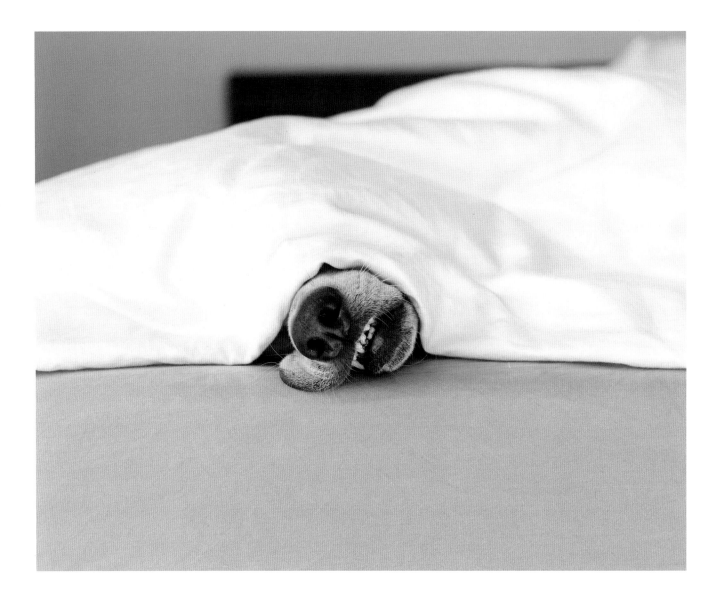

San Francisco, CA

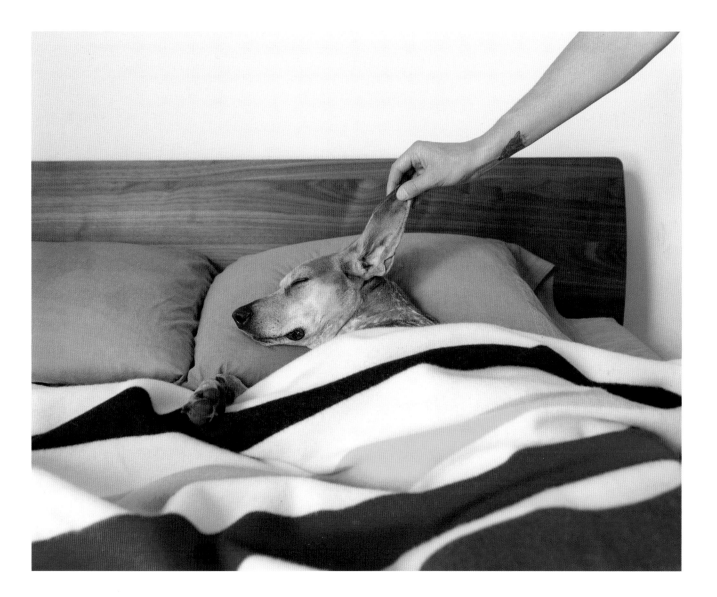

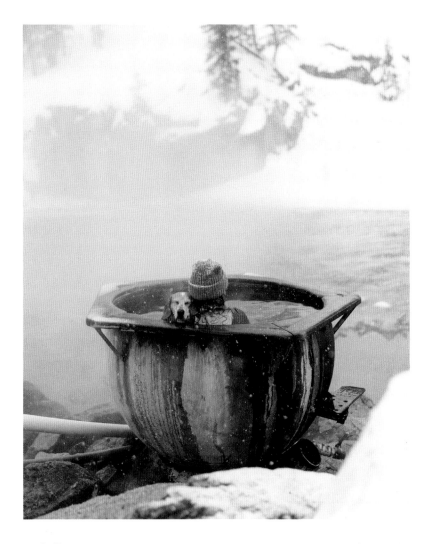

⬈ **Emily** / Stanley, ID ⟶ Stanley, ID

This little slice of hot spring heaven is a gem. Pun intended.
'Cause I took this photo in Idaho, the Gem State. I love
finding little spots like this when I'm traveling. The sort
of places that are known only to locals.

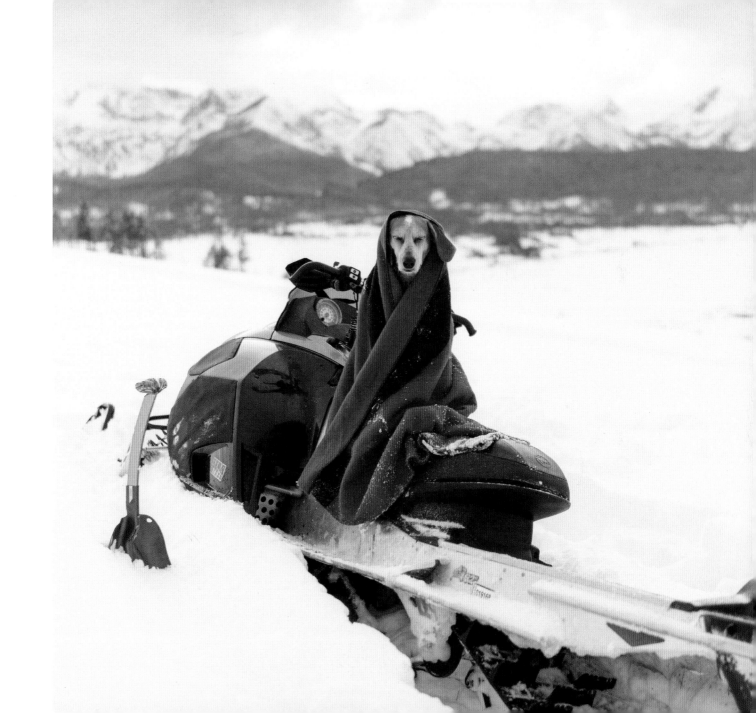

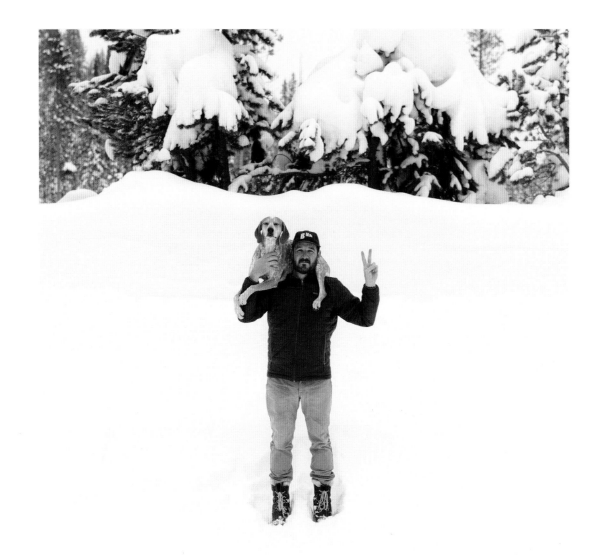

Maddie & Me / Stanley, ID

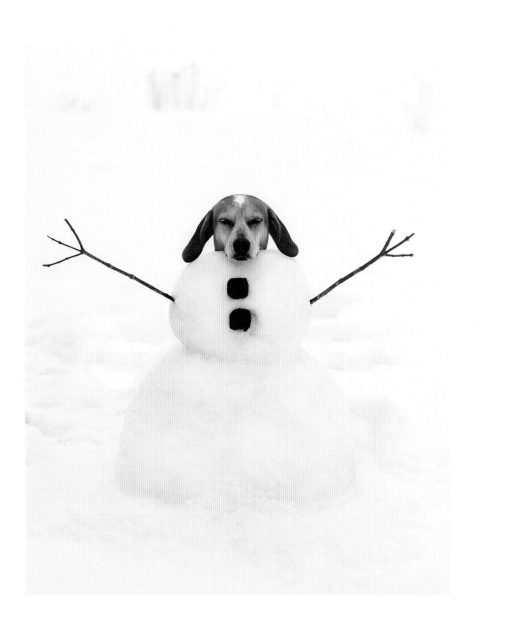

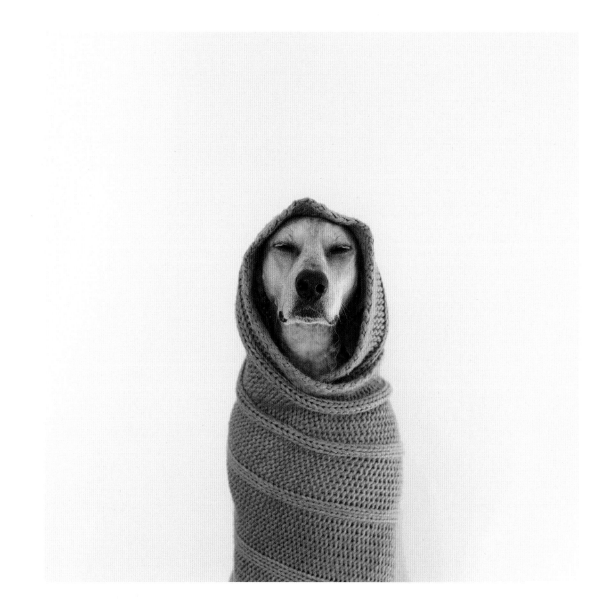

Nashville, TN

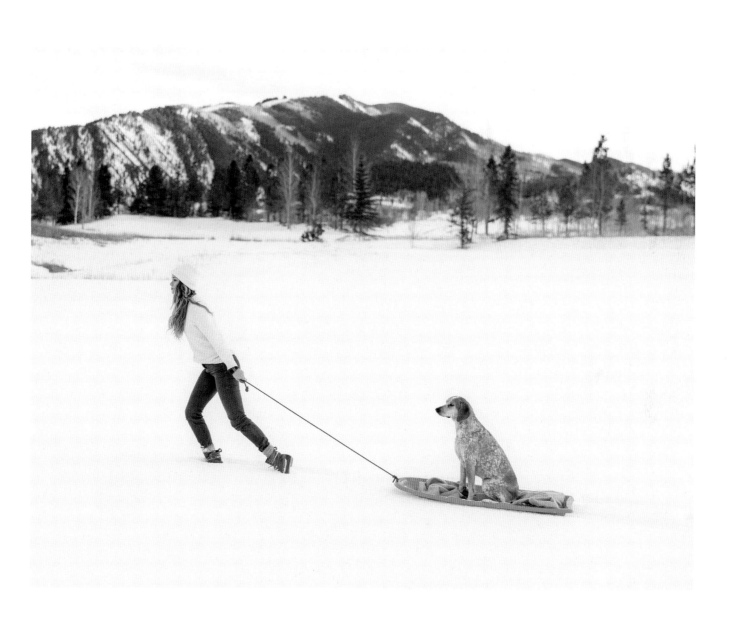

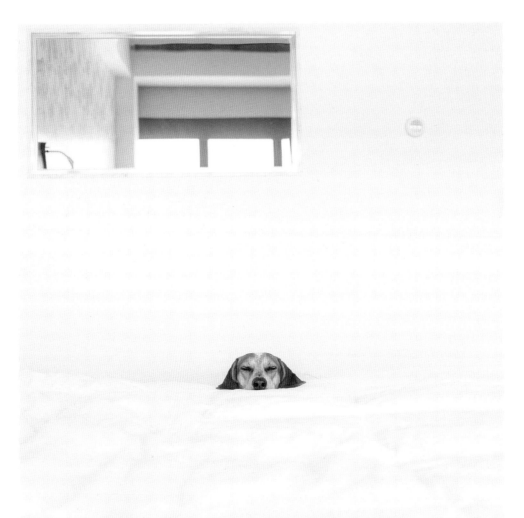

↗ **Wythe Hotel /**
Brooklyn, NY

→ Nashville, TN

Maddie always sleeps under the covers. I think it's just how hounds do things—they love to nest and get cozy. This photo came about when she was sleeping one morning. I tucked her in and ended up with an outline of her shape. I love this image, it makes me smile.

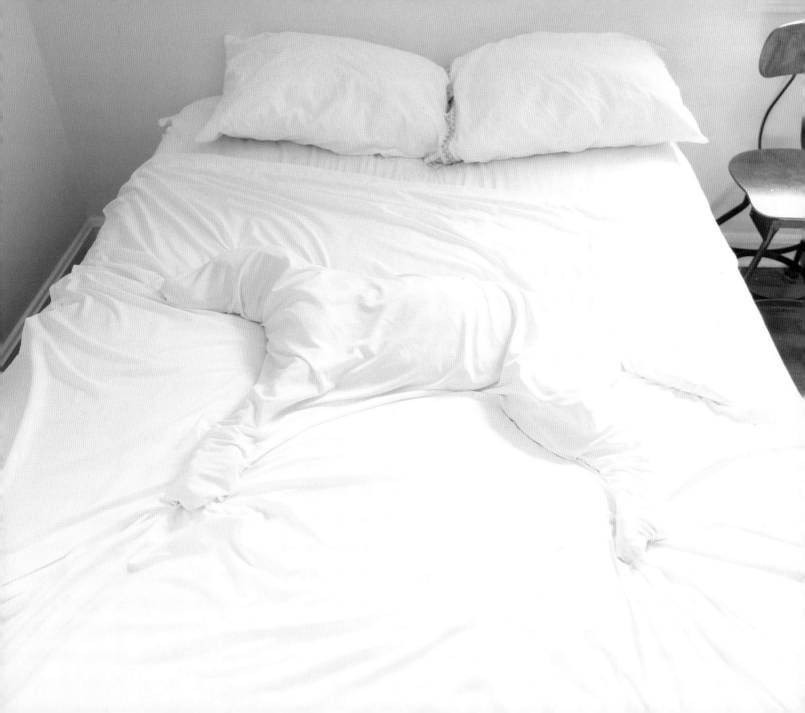

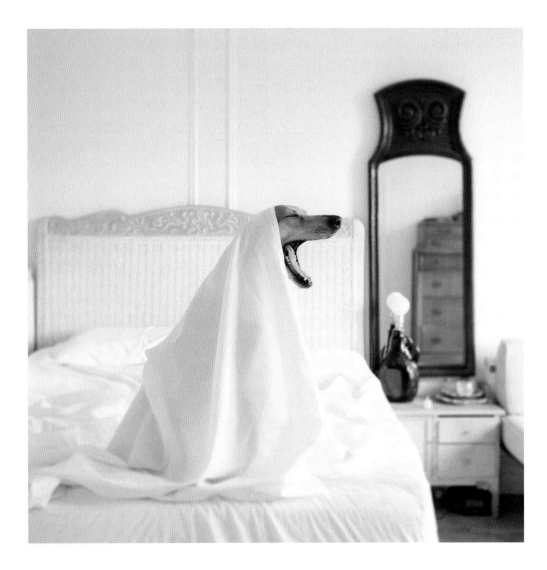

Brooklyn, NY

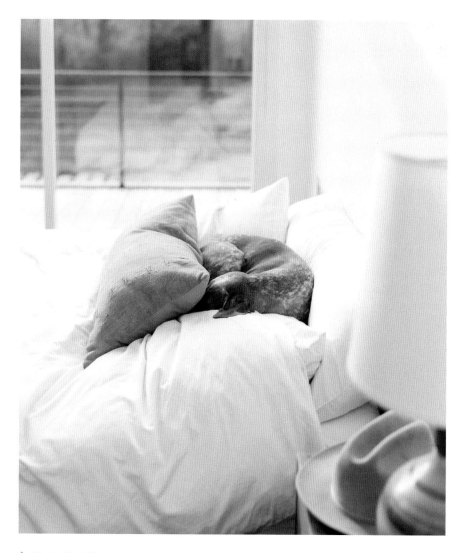

↑ Nashville, TN

My first home! Feels odd even typing those words. After years of living on the road I never thought I'd have a homestead. Not just a house, ya know, but a place I really love. A place I feel inspired to be and a place where I feel at rest. Grateful this little house in Nashville is where I hang my hat.

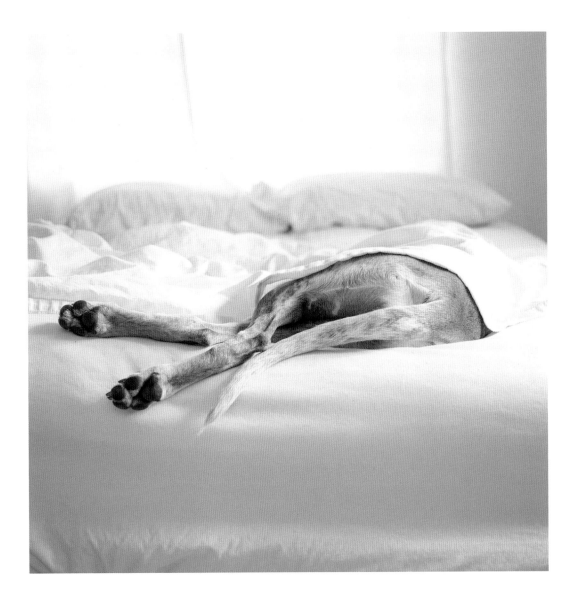

Brooklyn, NY

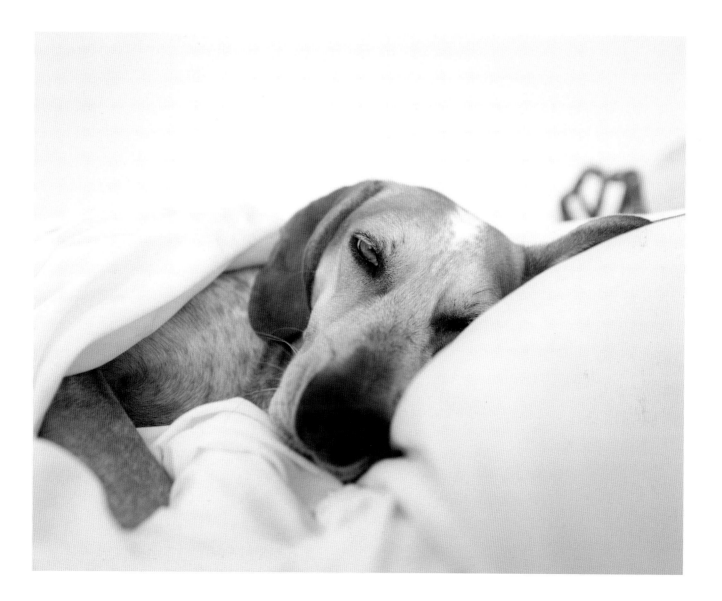

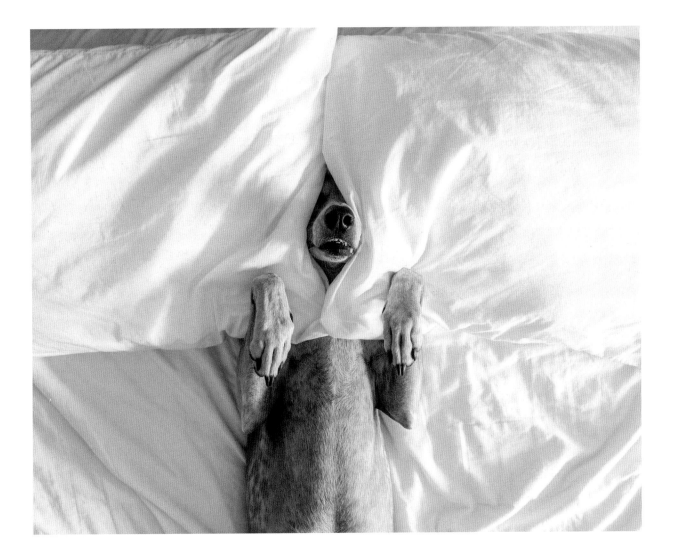

↗ **Roadside motel** / Las Cruces, AZ

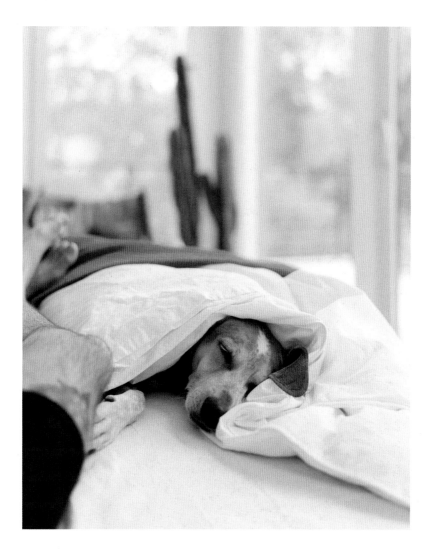

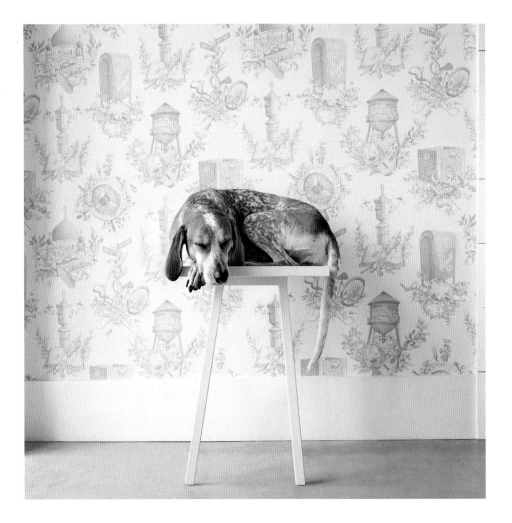

↗ **Wythe Hotel** / Brooklyn, NY

You might have seen this image before, on the book cover. Maddie is a funny dog—she really will climb up on things and just sit on them. Like the back of a couch or an end table. This image came about when my buddy Uncle Mo was staying at the Wythe. I noticed the color of the alarm clock stand. Maddie perched on it and then I had her lie down. I suppose that sounds simple but hopefully the magic is in the feeling of the photo.

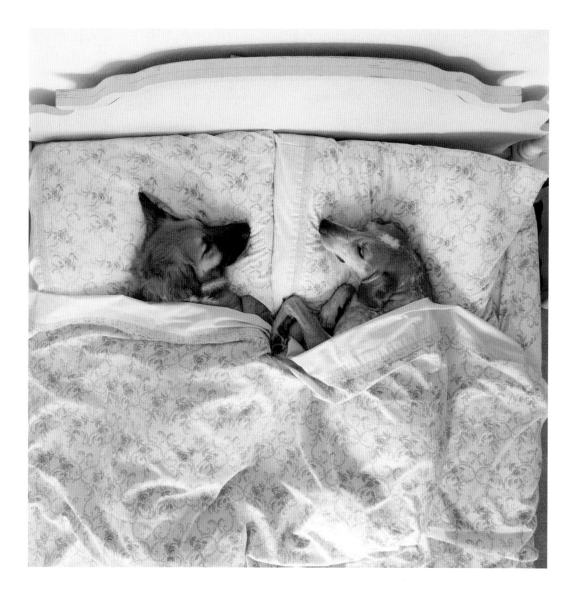

Eleanor & Maddie / Dripping Springs, TX

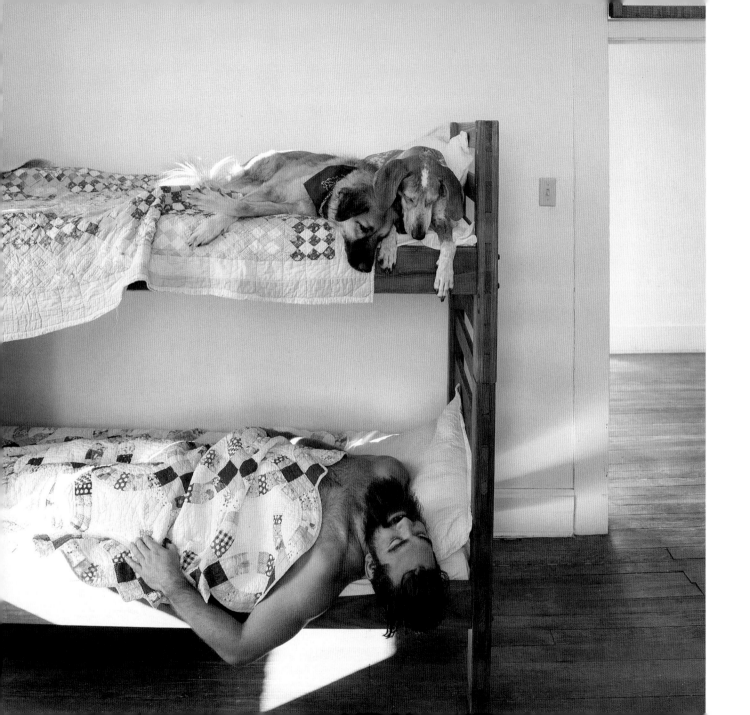

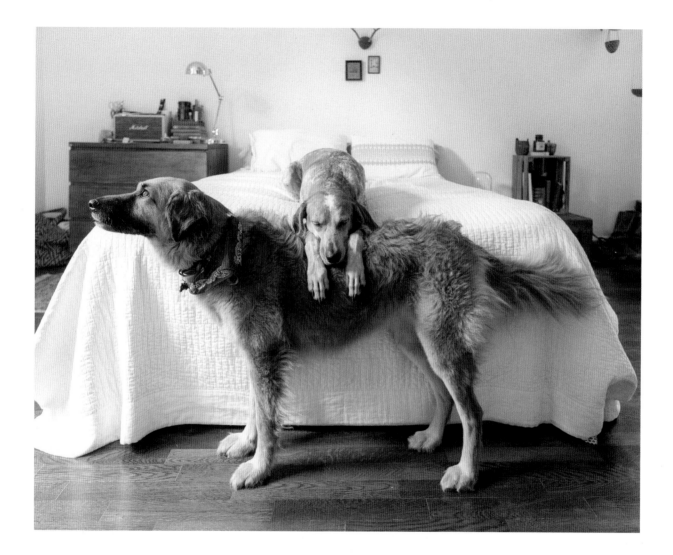

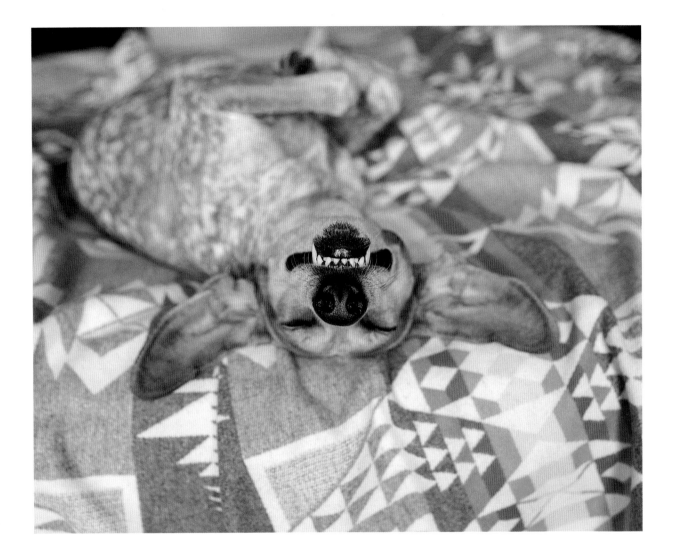

↗ Nashville, TN

⟶ **Ruthie** / Nashville, TN

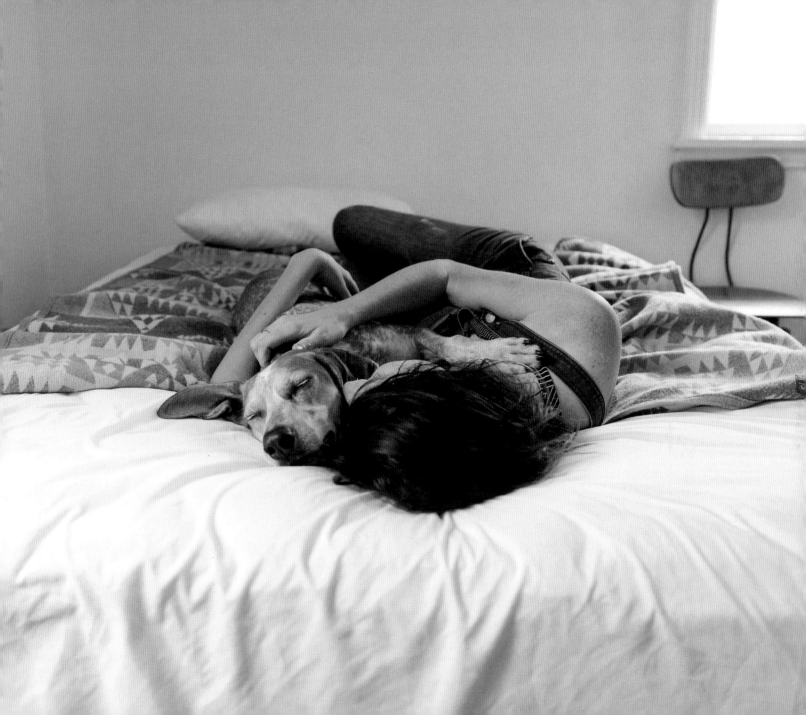

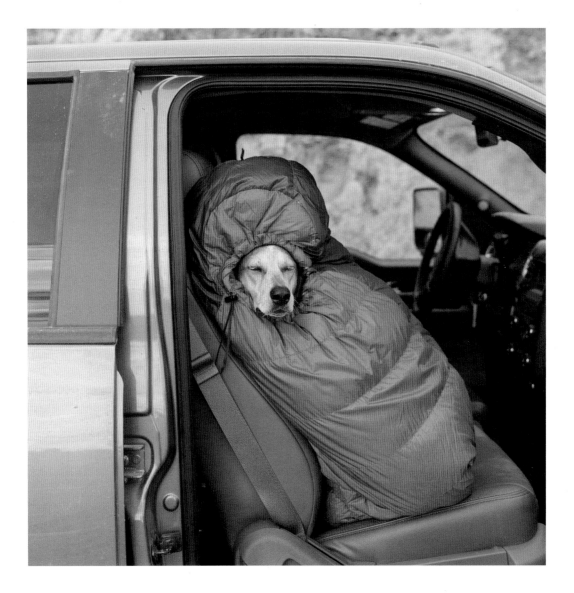

Moab, UT

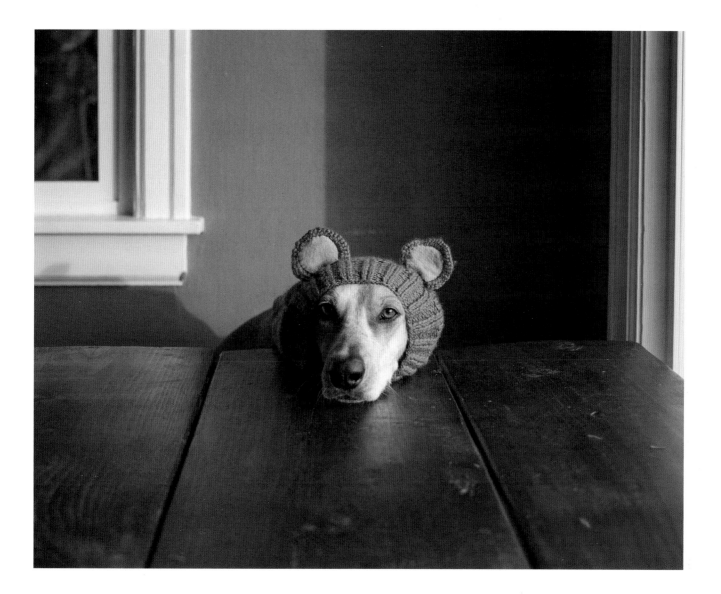

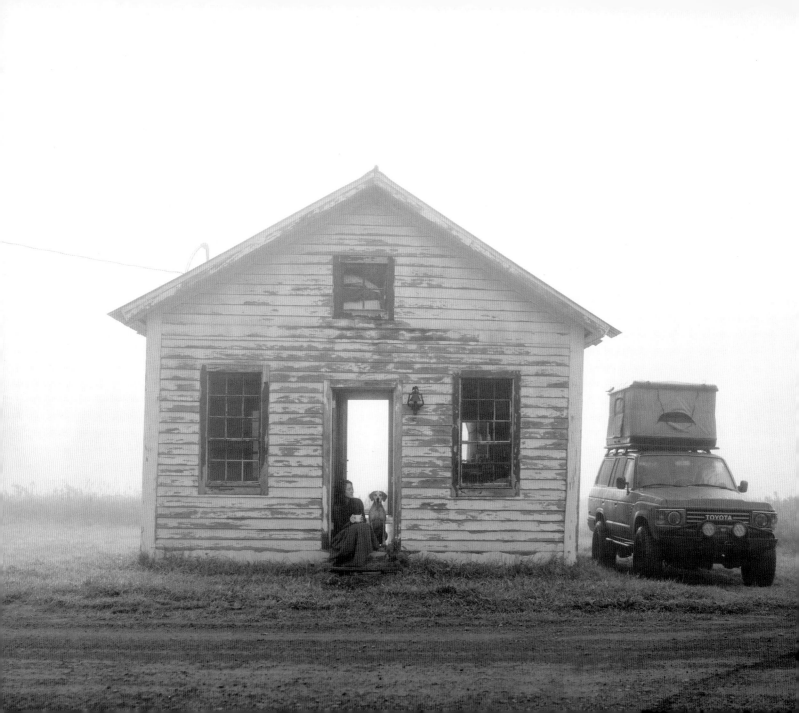

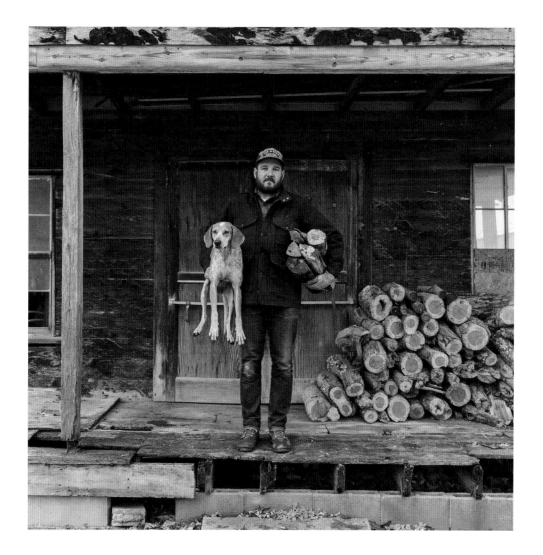

Self-portrait / Clarksville, TN

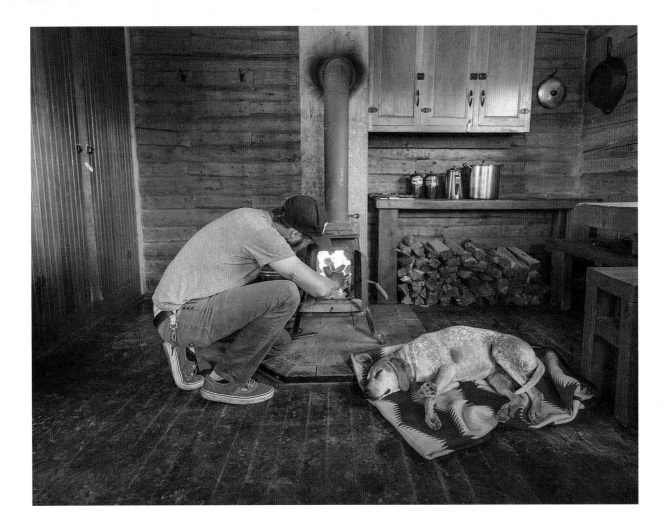

White River National Forest / Glenwood Springs, CO

I've traveled a fair bit with these two. The cozy feet you're looking at belong to my dear friend Josh Helund. We've been up and down the West Coast and across the United States, and he even came along when I got a wild hair to drive in every state of Mexico. But of all our adventures this little cabin in Colorado is my favorite.

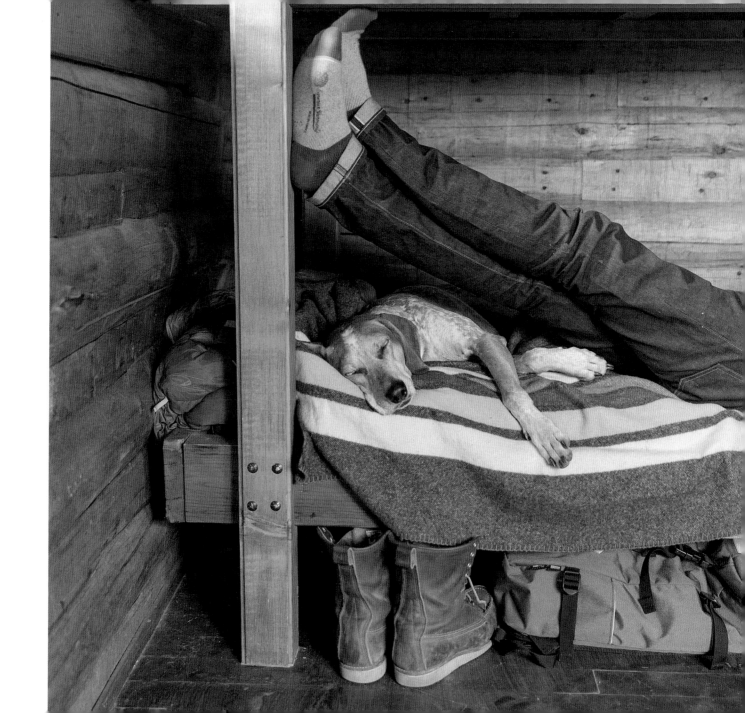

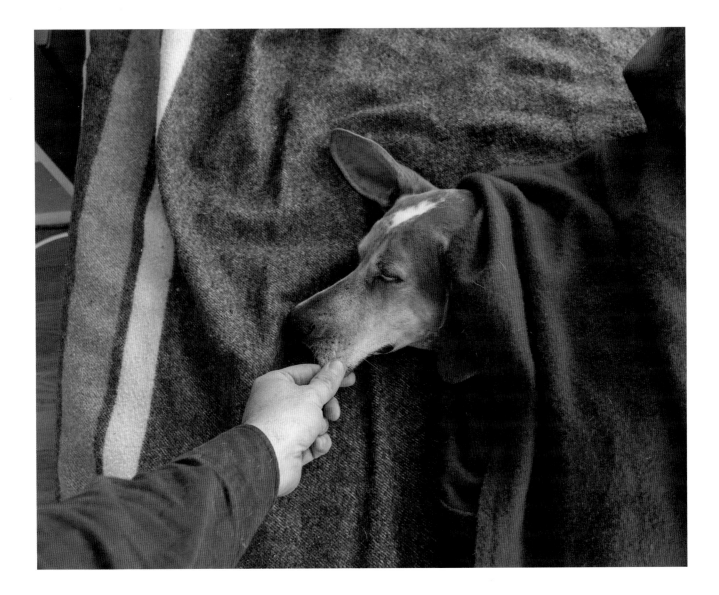

Nashville, TN

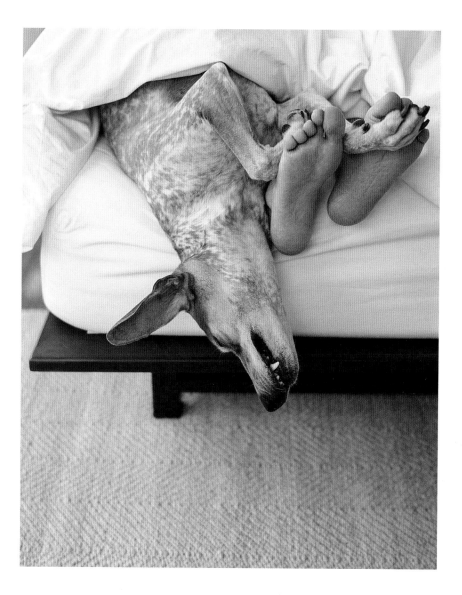

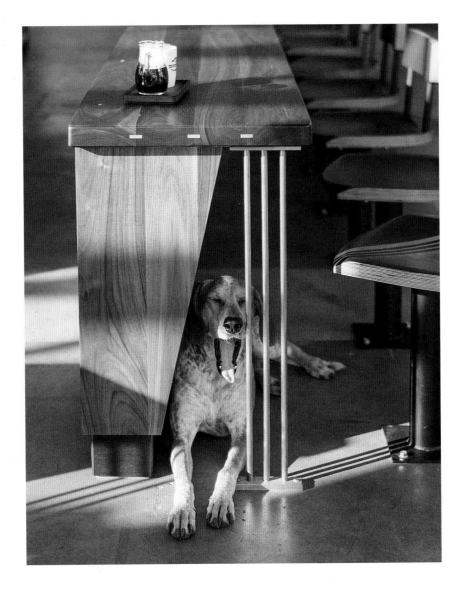

Barista Parlor / Nashville, TN

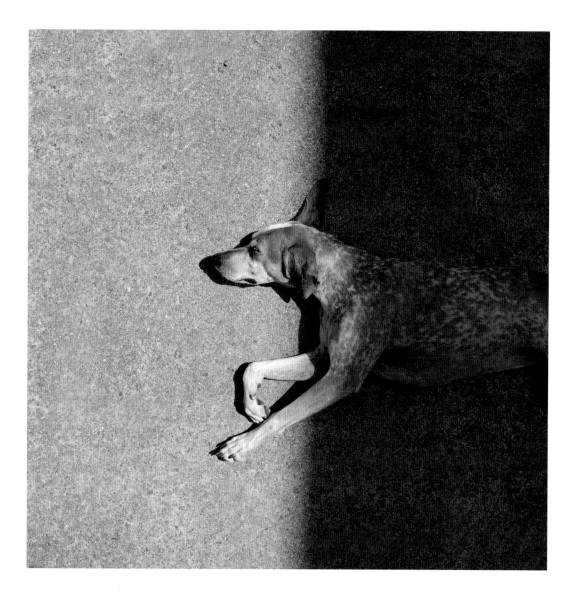

Nashville, TN

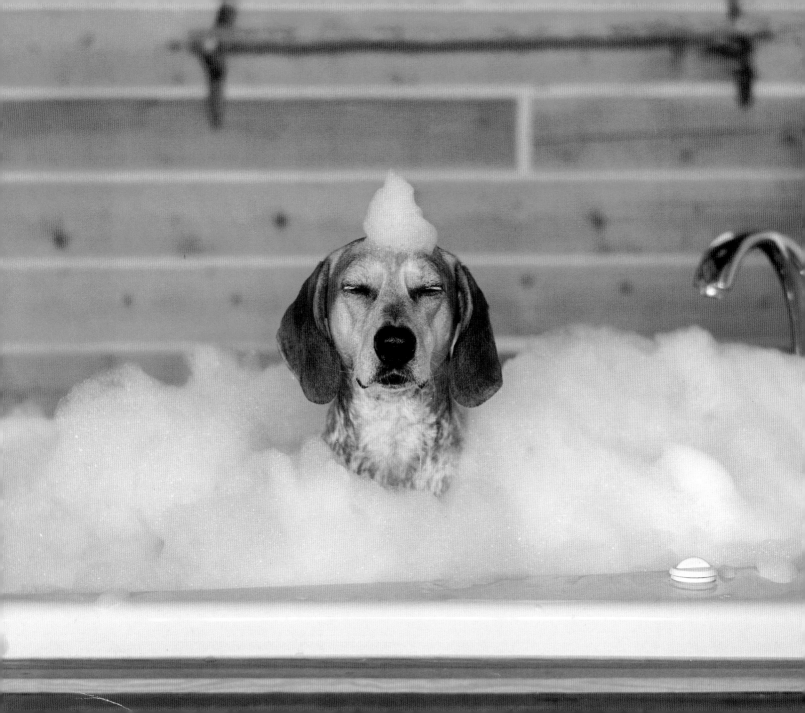

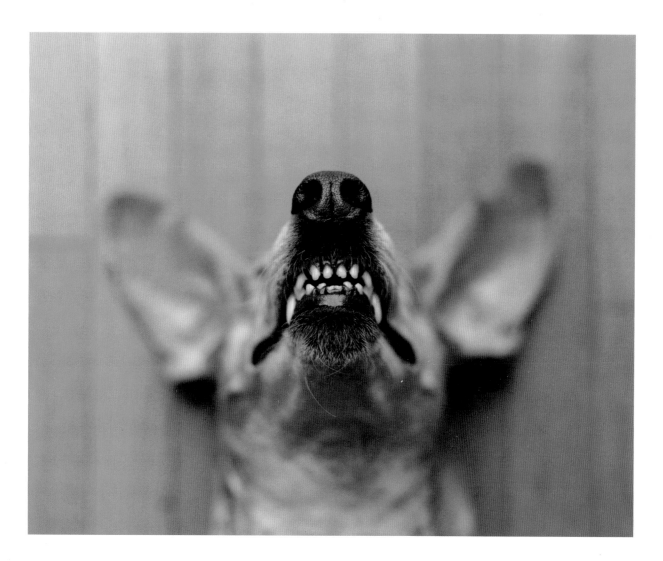

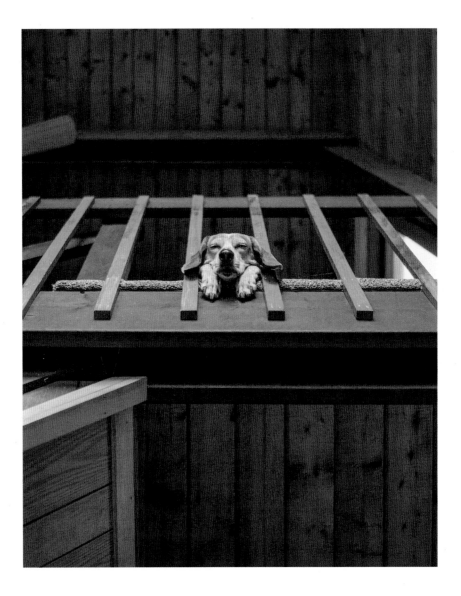

Denmark, ME

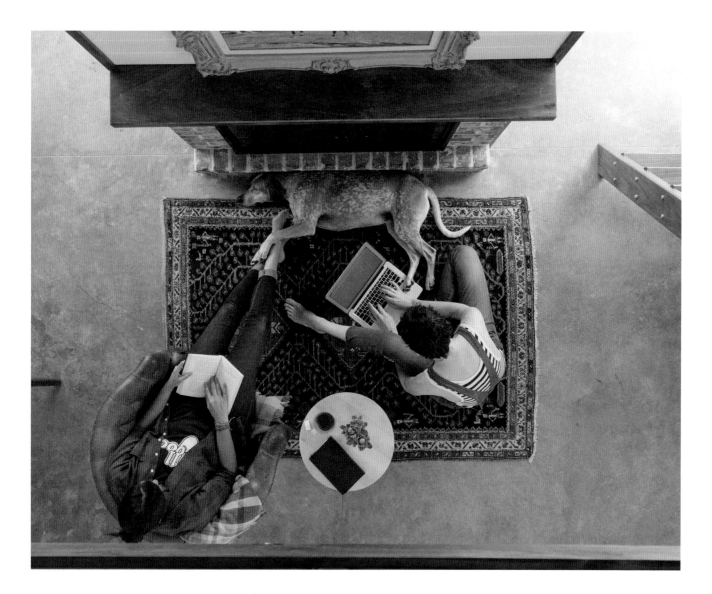

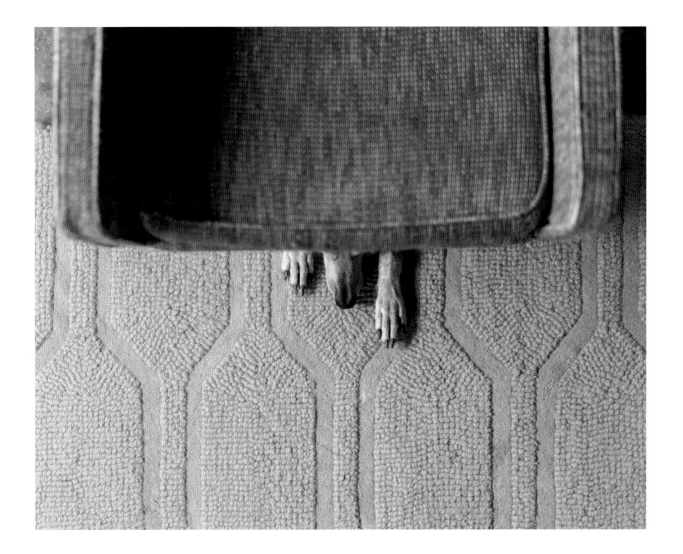

118 ↗ Nashville, TN

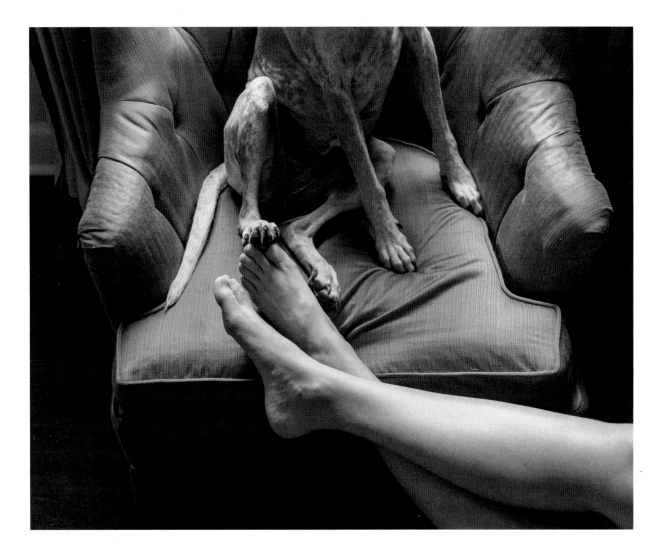

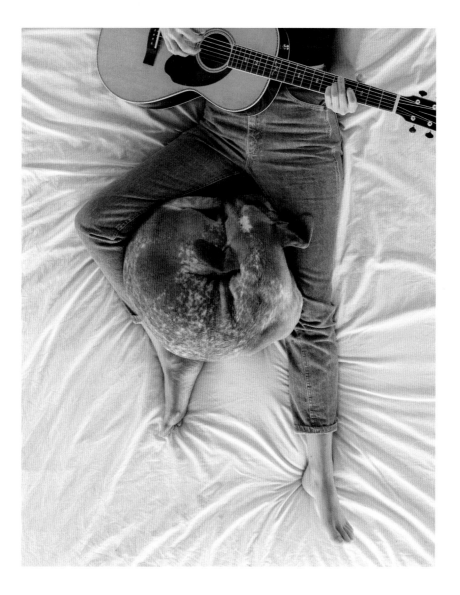

Bovina Center, NY

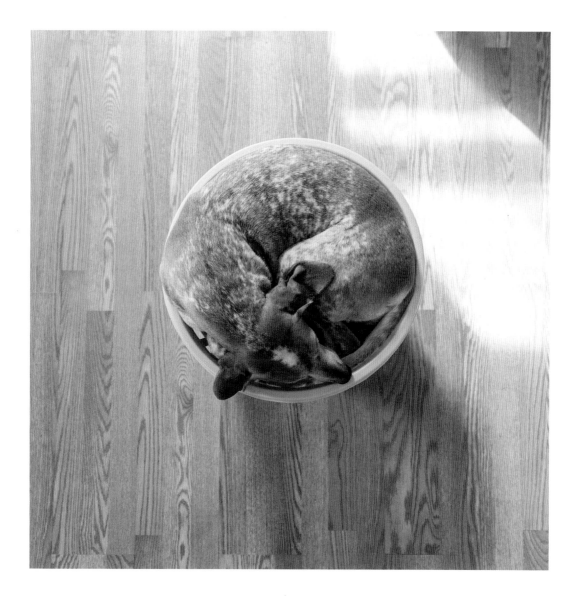

Sandpoint, ID

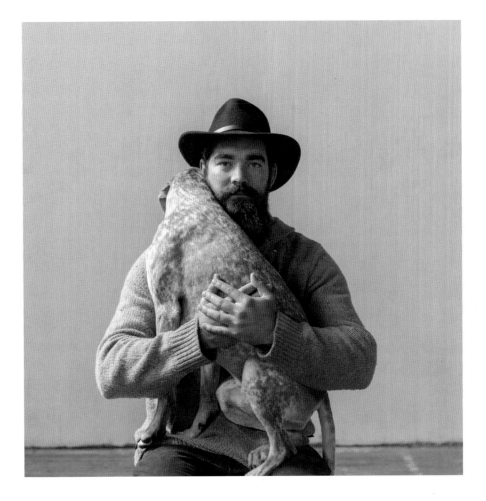

Garrett / Tehuacana, TX → Austin, TX

We were hanging at my buddy Matthew Mahon's house, and he pulled out this guitar to sing the sweetest song. He was playing a few chords that really started to pull at our heartstrings. I looked over at Maddie, and she was swaying back and forth, almost like she was in love. She meandered over to Matt's feet, circled a few times, and fell asleep right in that guitar case to his sweet lullabye.

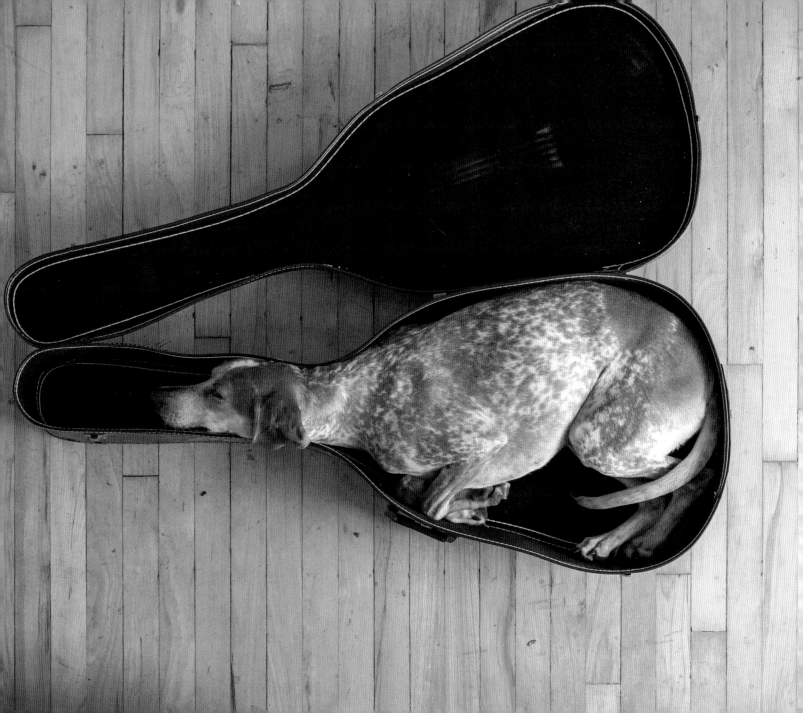

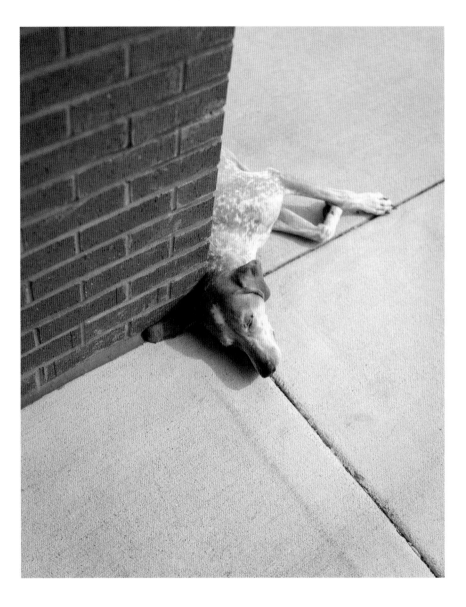

Nashville, TN

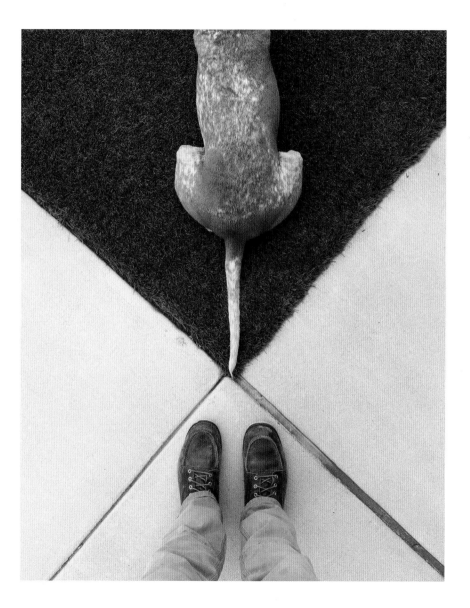

Nashville, TN

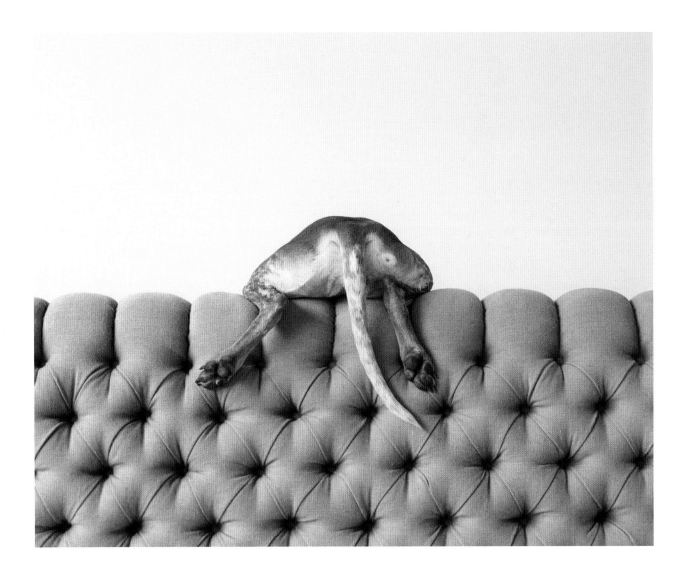

Brooklyn, NY

Nashville, TN

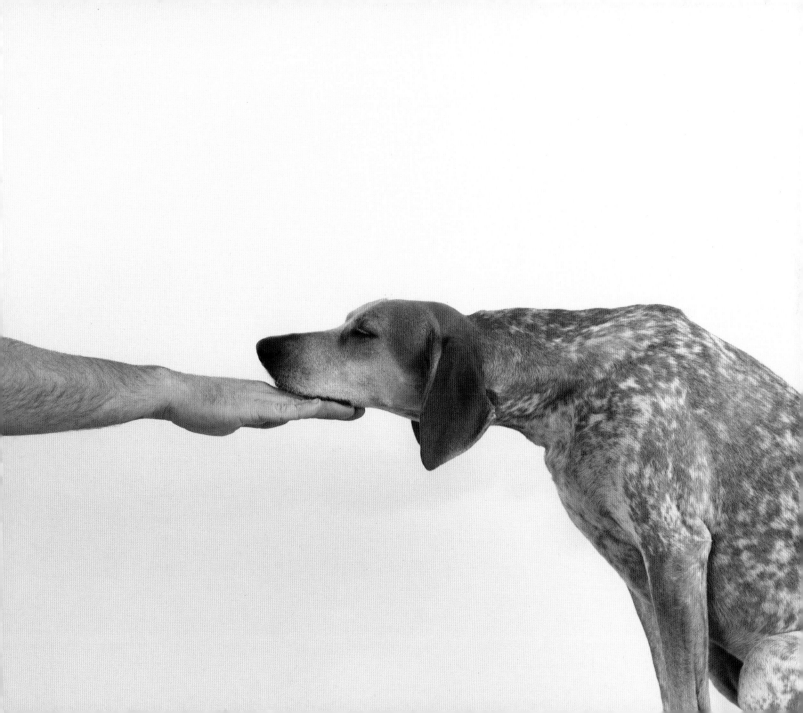

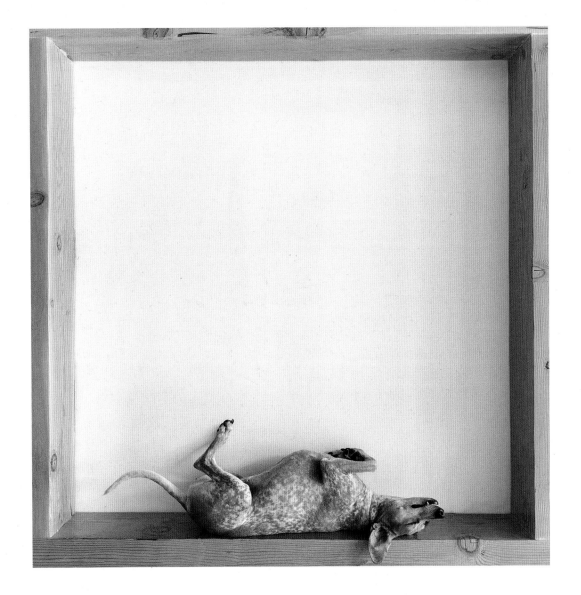

Steadbrook / Denver, CO

→ Flagler Beach, FL

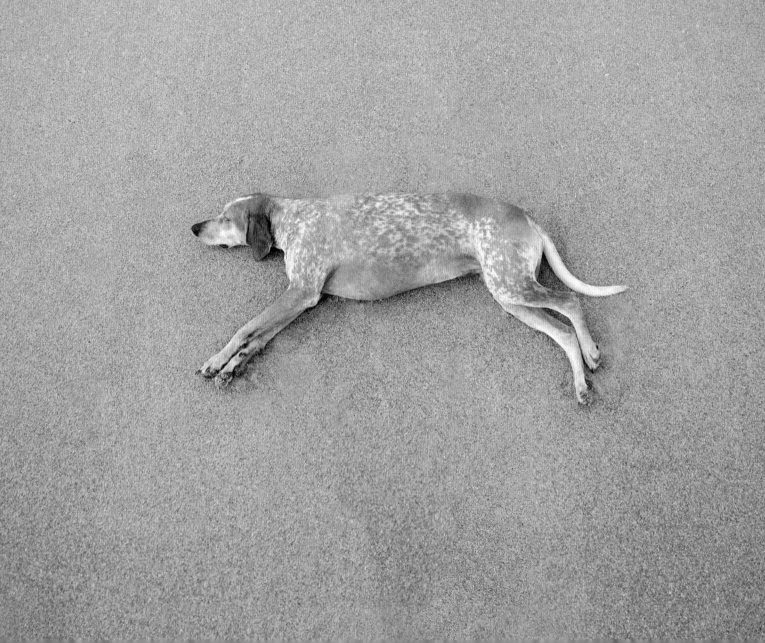

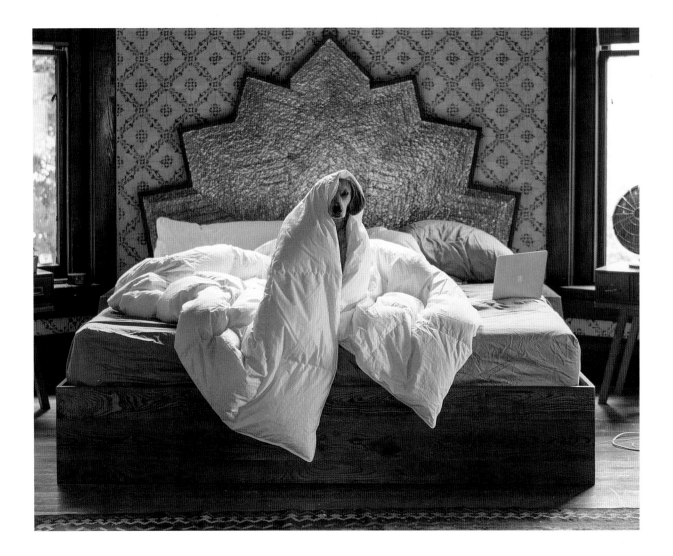

⚲ **Urban Cowboy B&B** / *Nashville, TN* → Seattle, WA

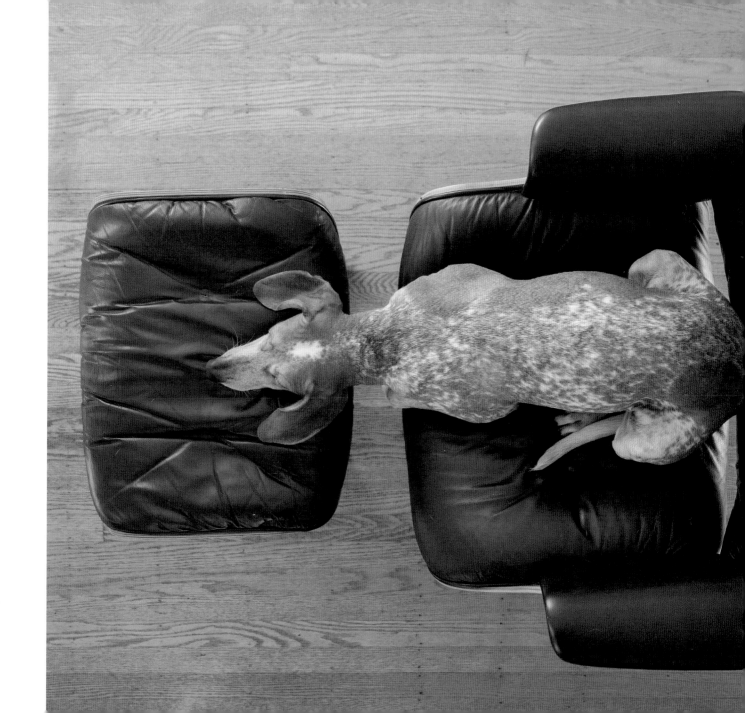

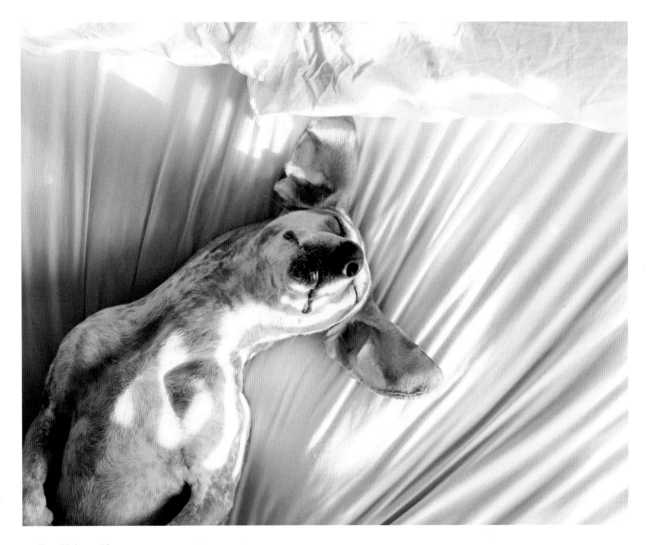

Des Moines, IA

I've come to love that Maddie is a snuggle bug. When I rescued her years ago I didn't know that I would love this quality in a dog. She's always getting under the covers and lying upside down in the bed. Most mornings she stays in bed even after I get up, but she'll come running when she hears food hitting her bowl—it may be the cutest thing ever.

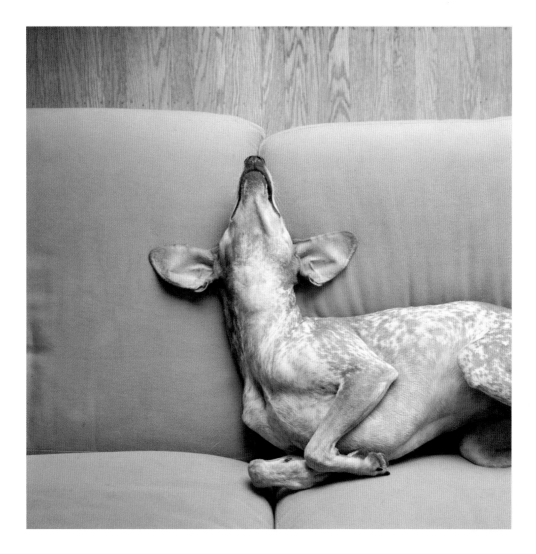

Seattle, WA

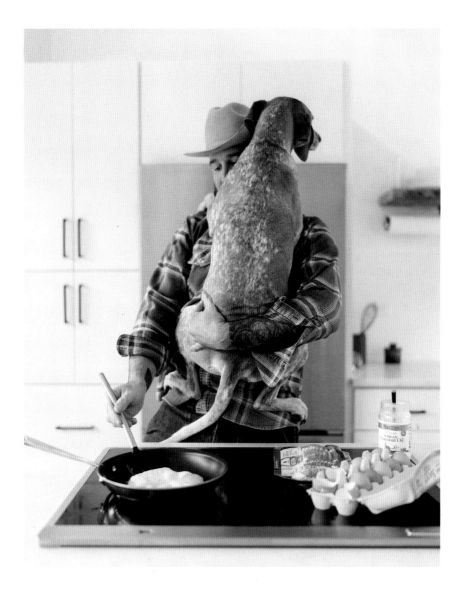

Home / Nashville, TN

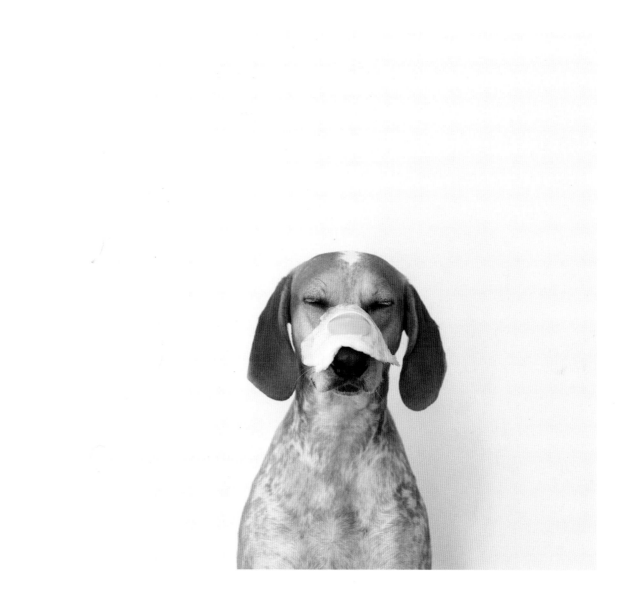

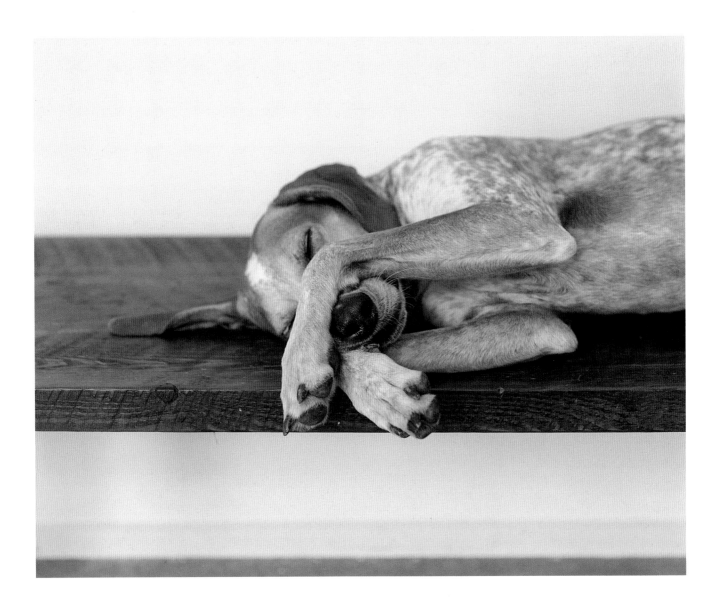

⌐ Atlanta, GA

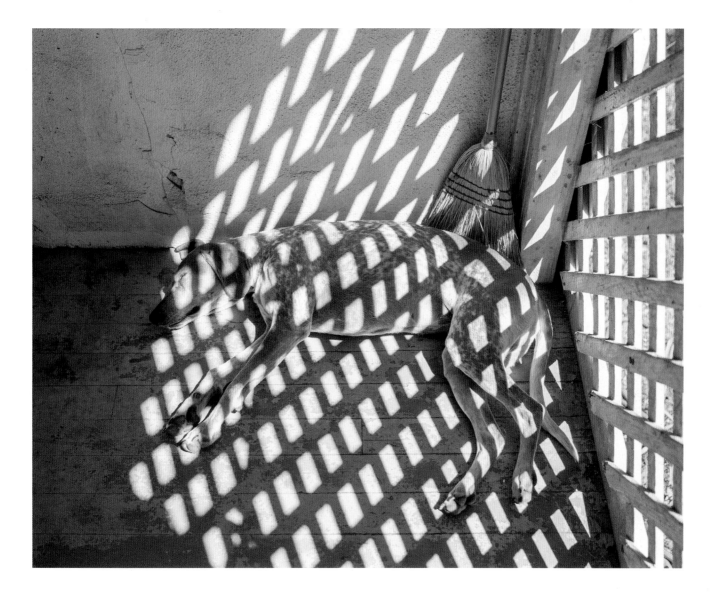

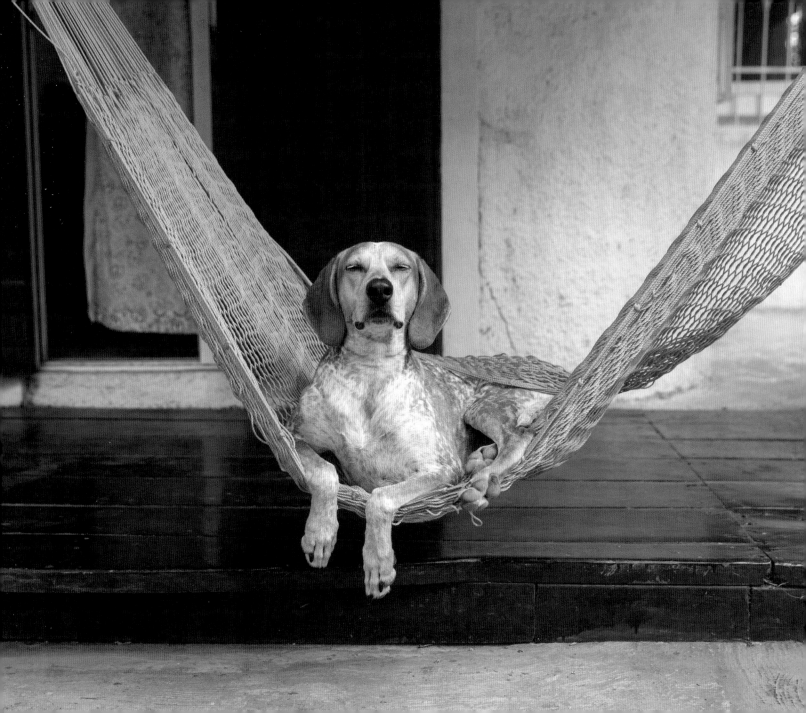

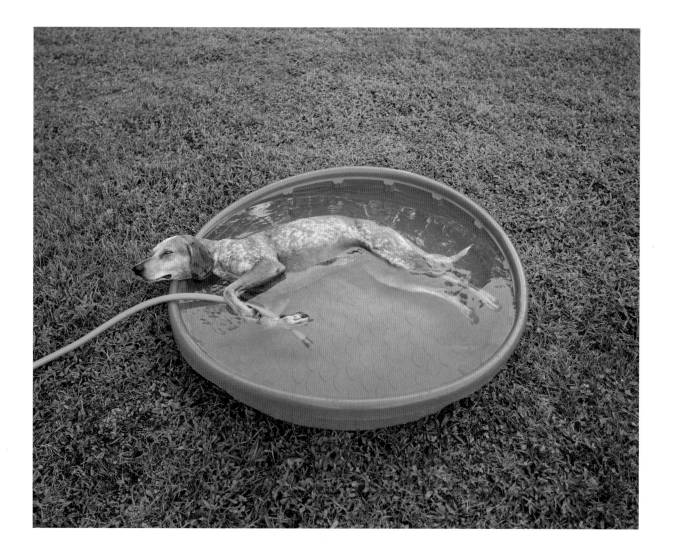

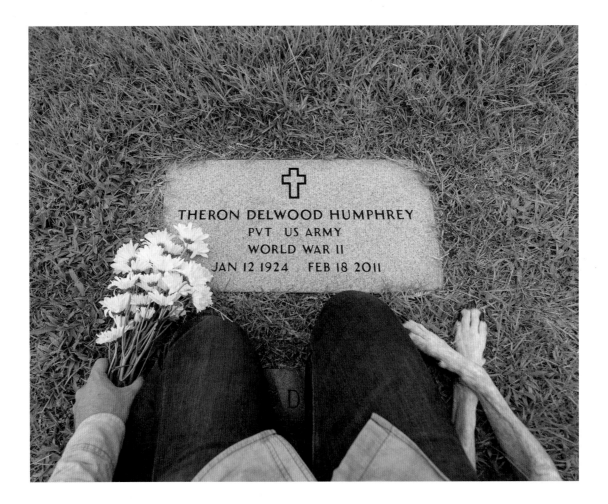

↗ Maysville, NC

→ **Camp Wandawega** / Elkhorn, WI

My granddaddy, Theron Delwood Humphrey. He and his six brothers served in World War II. He worked a hundred-acre farm and was a mechanic most of his life. Some of my fondest memories are riding on the back of his Allis-Chalmers D14 tractor. He was full of Southern idioms, but the one that sticks with me is "faster than a cat can lick its whiskers."

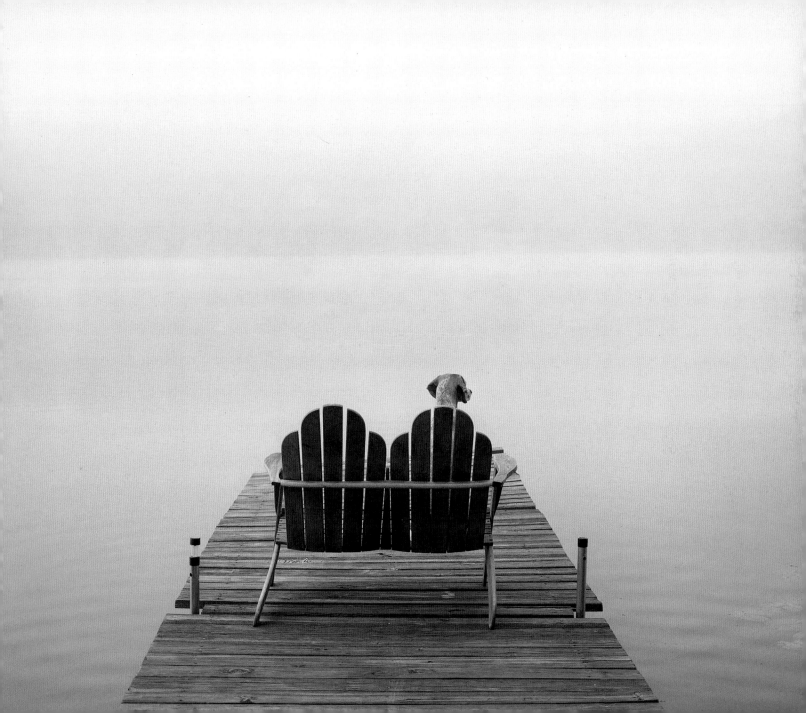

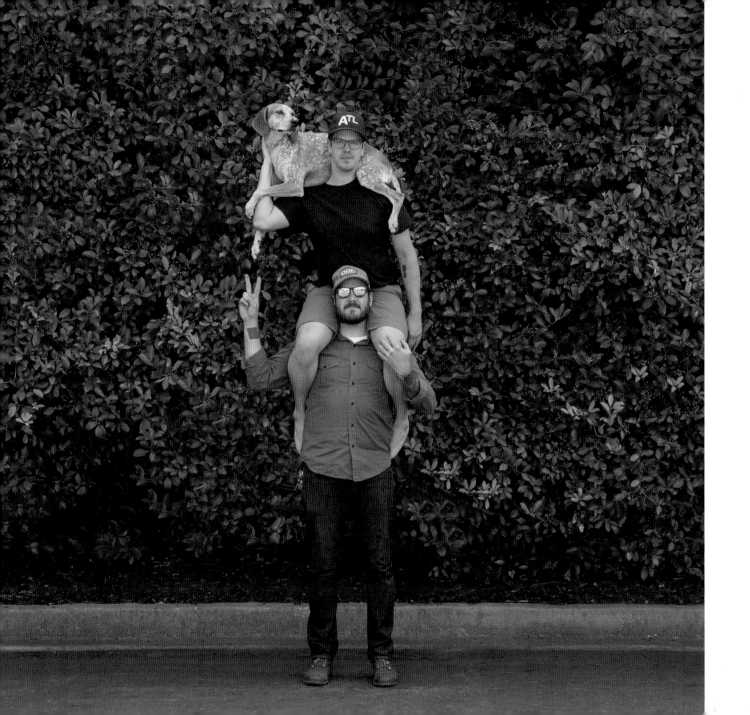

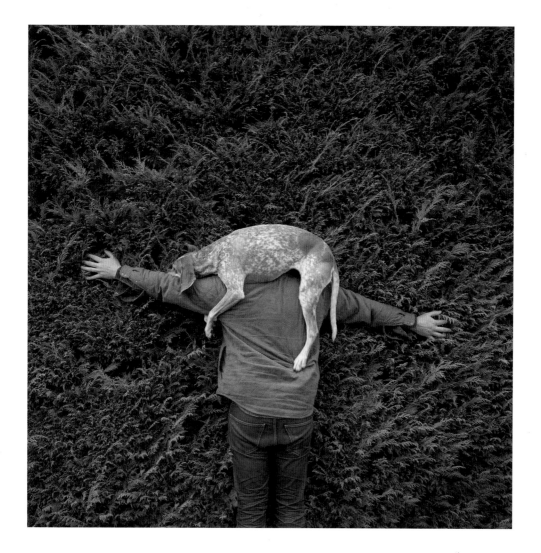

← Atlanta, GA

↖ Seattle, WA

This fella right here, Chris Barnes, has been through it all with me. Years
ago he helped me brainstorm a fifty-state documentary photography series,
which became my online handle, This Wild Idea. He's built all my websites.

143

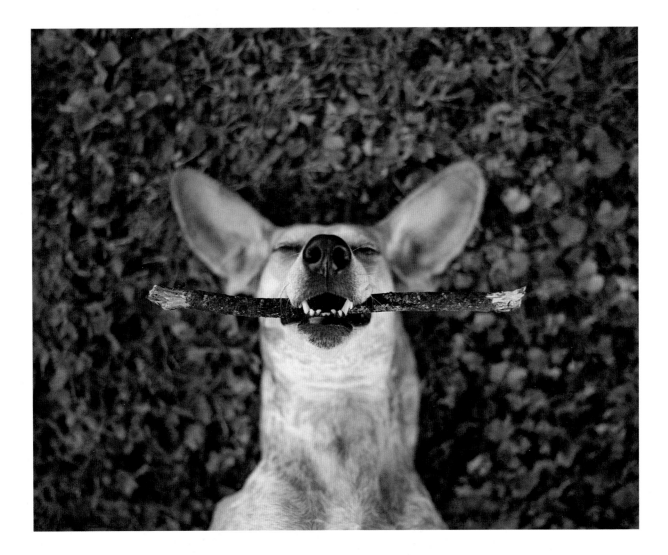

144 ✐ → Nashville, TN

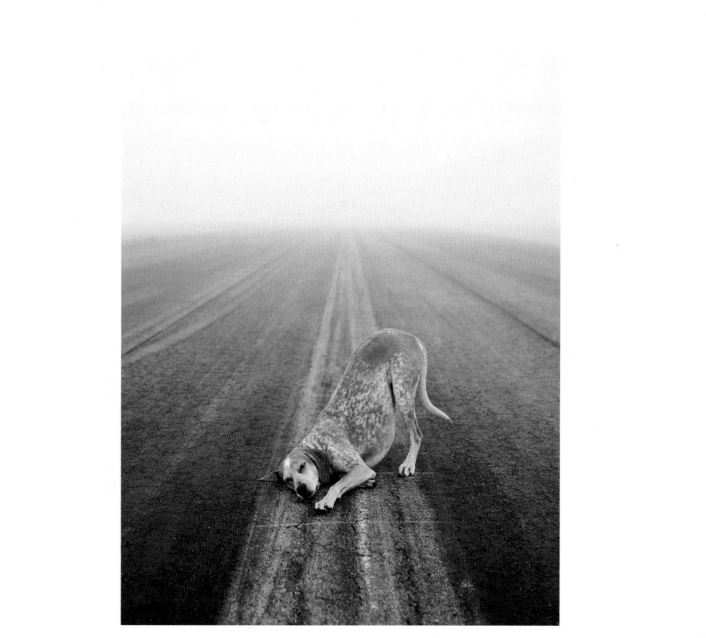

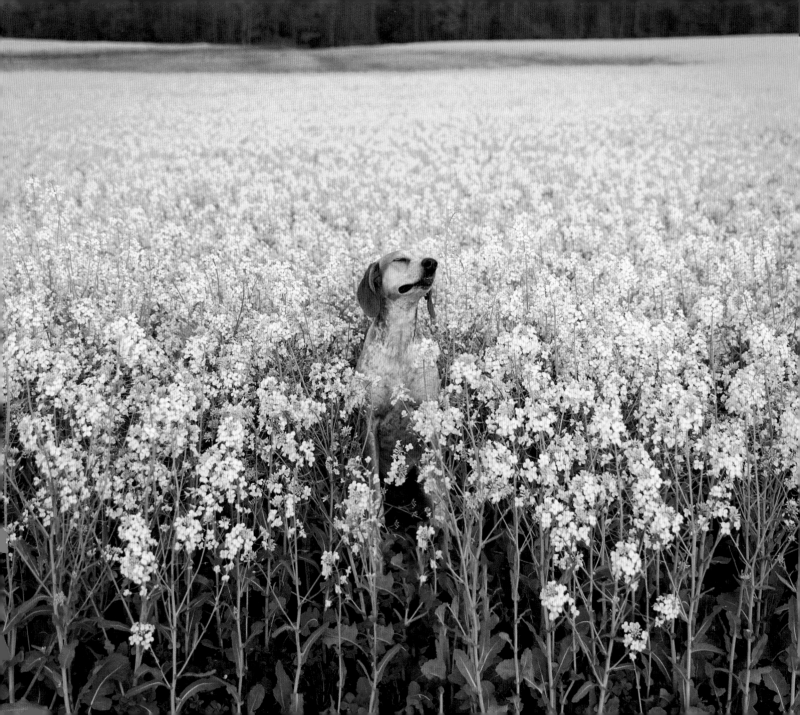

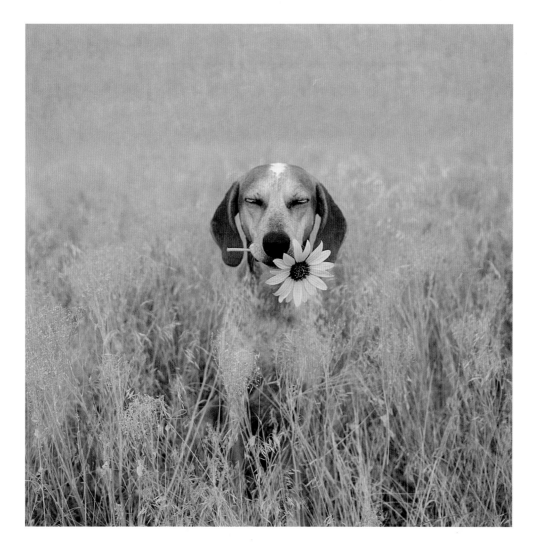

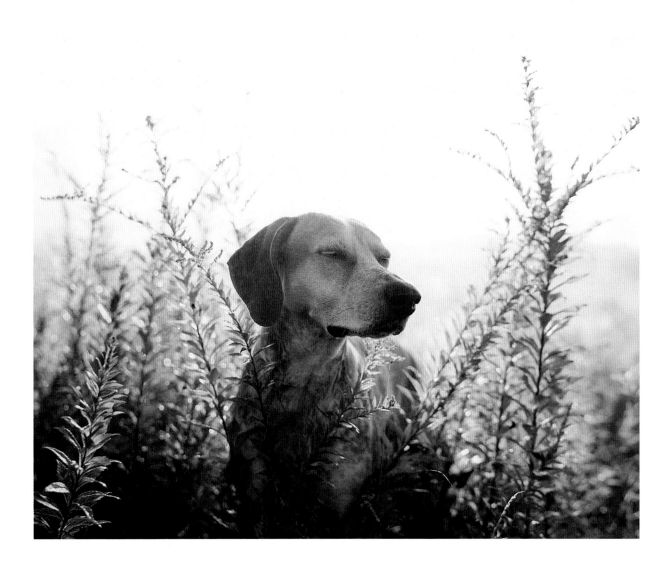

Bovina Center, NY

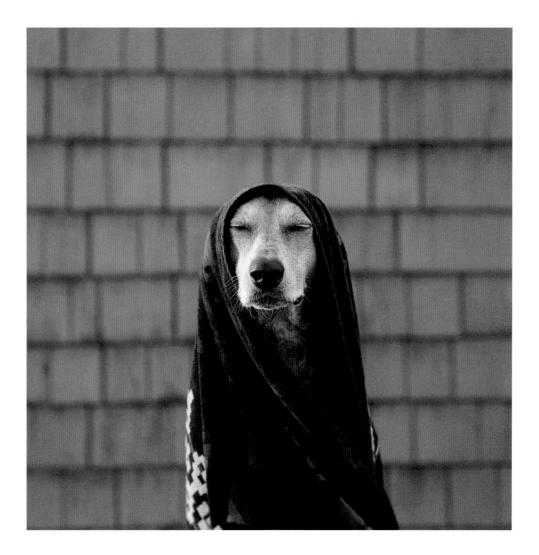

Sandown, NH

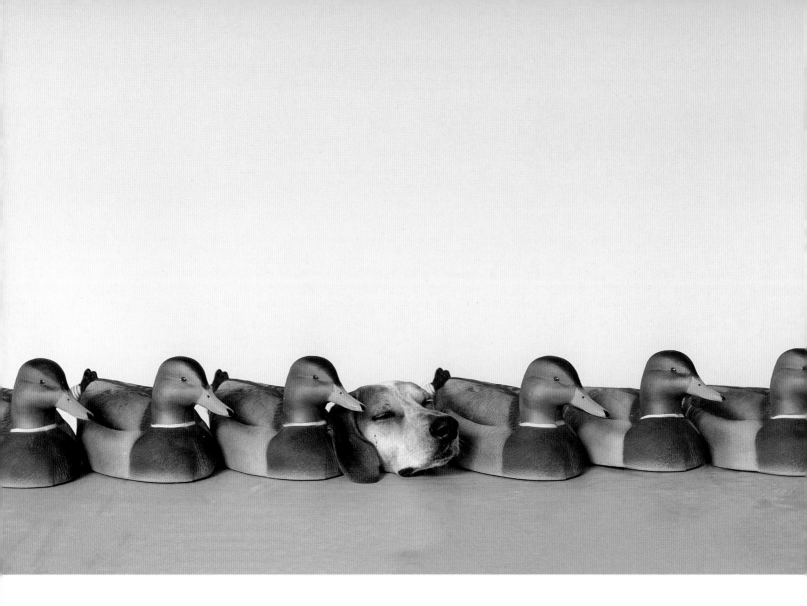

Atlanta, GA

→ Sandown, NH

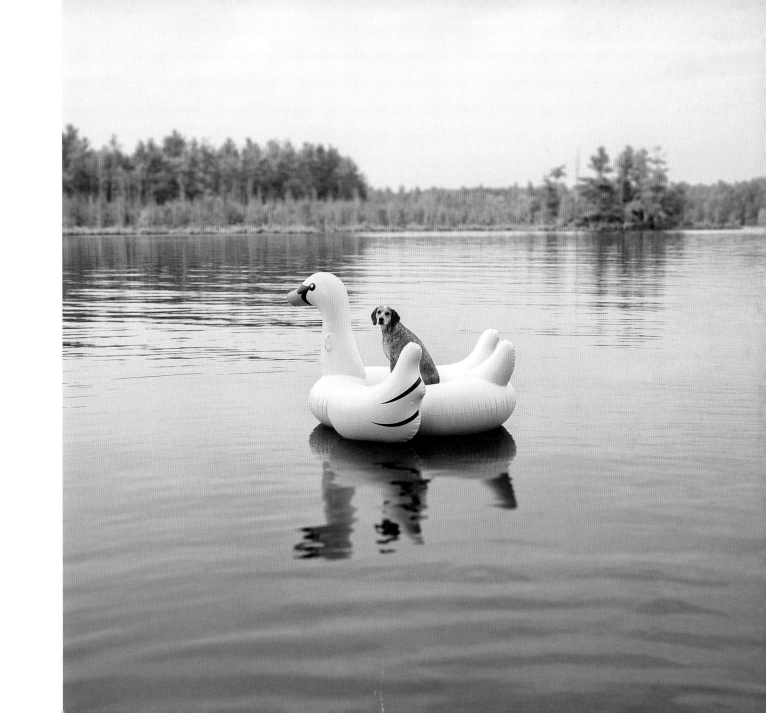

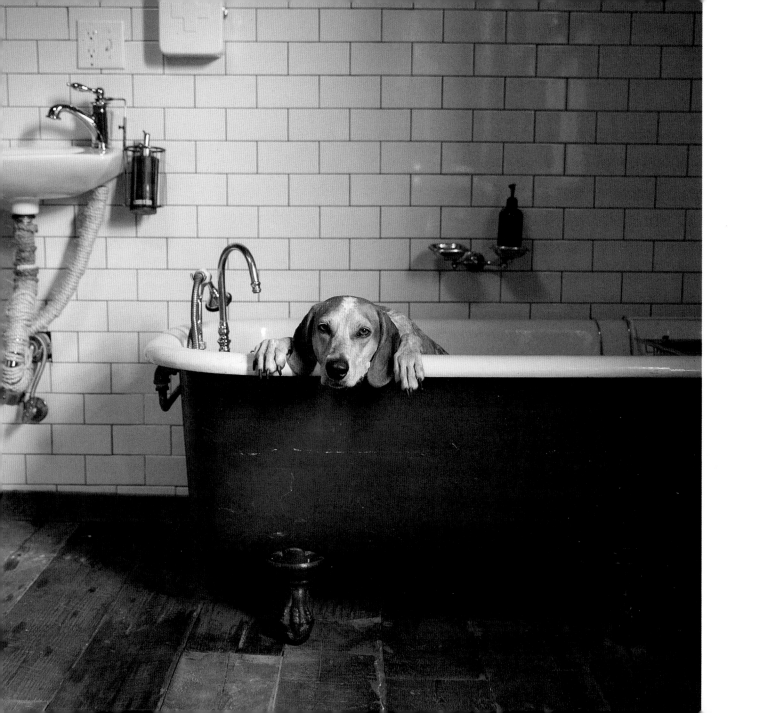

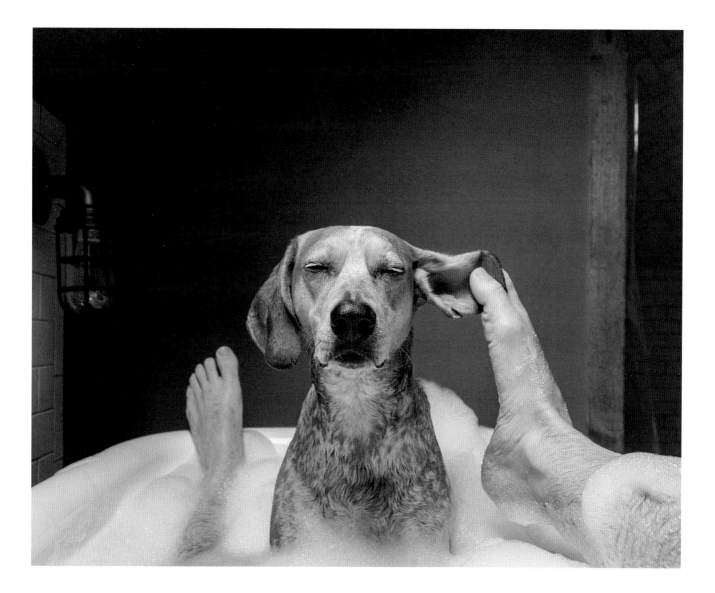

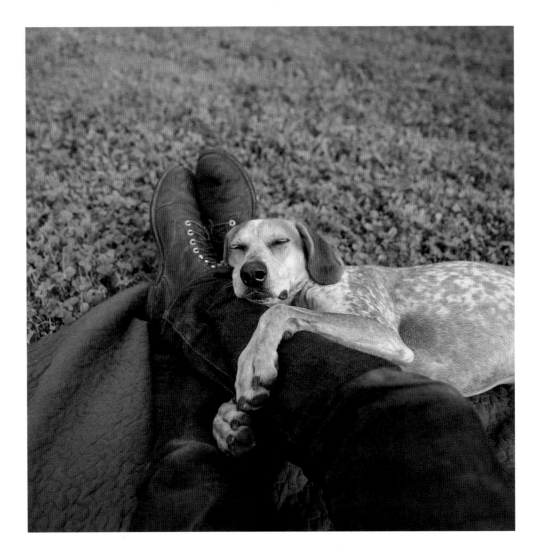

154 **Grant Park** / Atlanta, GA

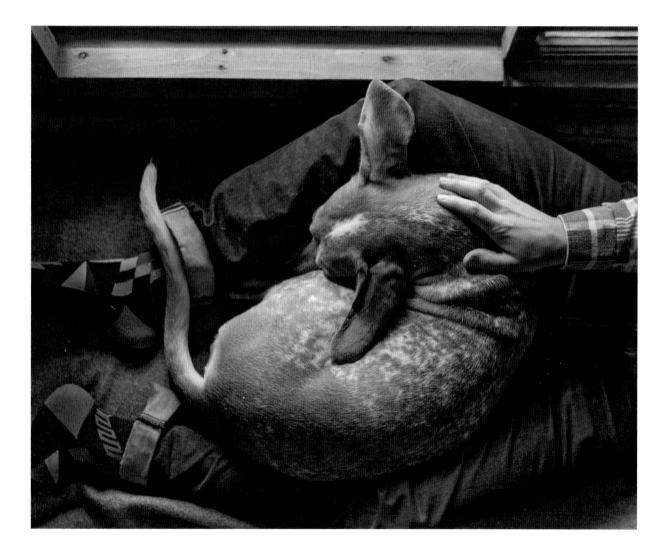

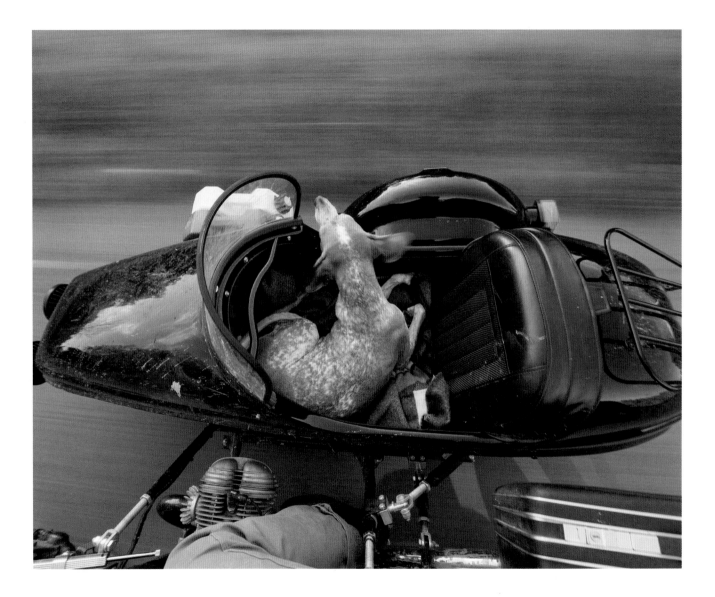

156 Back roads, TN

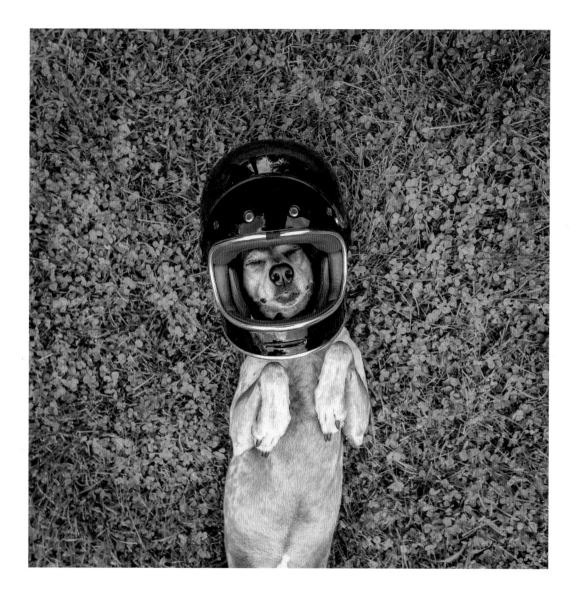

Nashville, TN

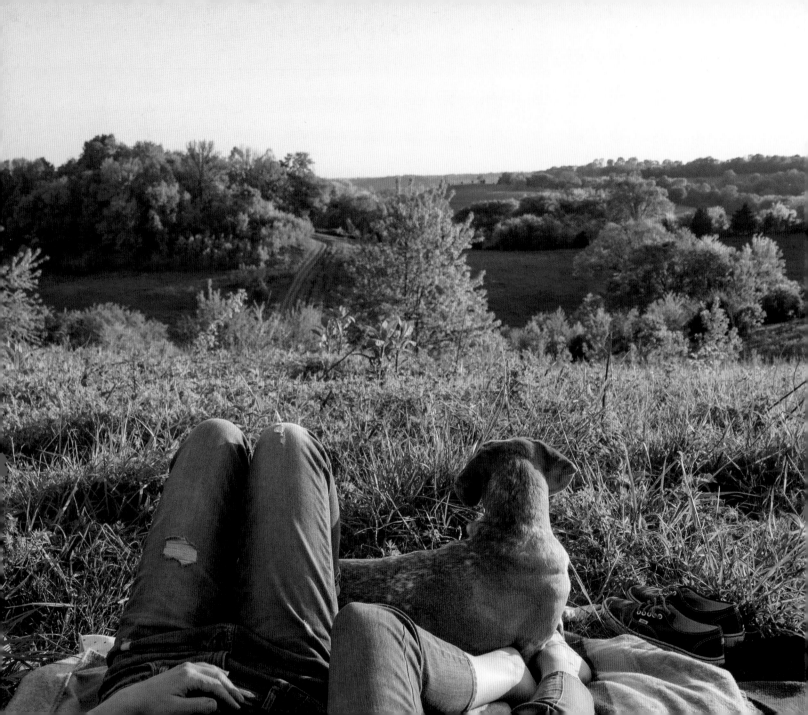

Acknowledgments

//

I wanna tip my hat in gratitude to all of y'all who have followed our adventures over the years. Truly, without y'all we wouldn't have been able to create this book. It's a blessing to be able to wake up and explore the world every day with my best friend, Maddie. The dream has always been to be a full time photographer and share our little slice of the world, so getting to actually live it is a special gift. Thank you.

I also wanna thank some dear friends who have loved me consistently over the years, at my best and worst: Chris Barnes, Josh Hedlund, Emily Blincoe, Tiffany Mitchell, Amber Rinck, Ruthie Lindsey, Phillip LaRue, Max Zoghbi, John Christian, Noe G, Michael O'Neal, Garrett Cornelison, Cubby Graham, Forrest Mankins, and my entire photography family over at Tinker Street. Thank you Jesse Miller for being not only a wonderful photo rep but a friend who has challenged me to grow along the way.

We're often stomping around the country in my ole 1987 Toyota Land Cruiser and one of the best mechanics around has kept us on the road: Tor Fab. Go see him in Seattle! He builds the very best Land Cruisers.

Thank you Donald Miller and Brené Brown for writing books that stirred me up on the inside, books that pushed me to become a better man. Last but not least, thank you Lindsey Singleton, you were a wonderful therapist. Your dedication to helping folks heal old wounds and become the healthiest version of themselves is good work.

Make something you love every day, y'all!

Editor: Samantha Weiner
Designer: Darilyn Lowe Carnes
Cover lettering and endpaper illustration: Kyle Steed
Production Manager: Kathleen Gaffney

Library of Congress Control Number: 2017930311

ISBN: 978-1-4197-2675-0

Printed and bound in China
10 9 8 7 6 5 4 3 2 1

Abrams Image books are available at special discounts when purchased in quantity for
premiums and promotions as well as fundraising or educational use. Special editions
can also be created to specification. For details, contact specialsales@abramsbooks.com
or the address below.

ABRAMS The Art of Books
115 West 18th Street, New York, NY 10011
abramsbooks.com